Video
Spaces

D1441642

The Museum of Modern Art

Distributed by Harry N. Abrams, Inc., New York

Video Spaces:

Eight Installations

by Barbara London

Published on the occasion of the exhibition *Video Spaces: Eight Installations,* organized by Barbara London, Associate Curator, Department of Film and Video, The Museum of Modern Art, New York, June 22–September 12, 1995.

This exhibition is supported in part by grants from The Japan Foundation, individual members of The Contemporary Arts Council of The Museum of Modern Art, and the Canadian Consulate General, New York.

Transportation assistance has been provided in part by Japan Airlines.

Copyright © 1995 by
The Museum of Modern Art, New York

Library of Congress Catalogue Card Number 94-073386

ISBN 0-87070-646-2 (MoMA/T&H)
ISBN 0-8109-6146-6 (Abrams)

Produced by the Department of Publications
The Museum of Modern Art, New York
Osa Brown, Director of Publications
Edited by Alexandra Bonfante-Warren and Barbara Ross Geiger
Designed by Emsworth Design, New York
Production by Marc Sapir
Printed by Meridian Printing, East Greenwich, Rhode Island
Bound by Mueller Trade Bindery, Middletown, Connecticut

Published by The Museum of Modern Art
11 West 53 Street, New York, New York 10019

Distributed in the United States and Canada by Harry N. Abrams, Inc., New York, A Times Mirror Company

Distributed outside the United States and Canada by Thames and Hudson, Ltd., London

Printed in the United States

Cover: Background, Tony Oursler, *System for Dramatic Feedback,* 1994. Insets, photographic details of other installations in the exhibition.

Contents

Acknowledgments

In recent years video has merged with such fields as architecture, sculpture, and performance to create a dynamic new art form: video installation. *Video Spaces: Eight Installations* is the first exhibition at The Museum of Modern Art to feature some of the world's most recognized innovators in this area.

The organization of this exhibition has been a stimulating and rewarding experience, enriched by the wit of the artists themselves. I would like to thank Judith Barry and Brad Miskell, Stan Douglas, Teiji Furuhashi, Gary Hill, Chris Marker, Marcel Odenbach, Tony Oursler, and Bill Viola, who have been involved in every phase of the project. Not only is their work visually and conceptually insightful but they are congenial collaborators as well.

The contributions of numerous colleagues have insured the project's success. While I am unable to acknowledge all of them here, I want to mention several key people. The exhibition has been generously supported by the Museum's Video Advisory Committee and members of the Contemporary Arts Council, which have graciously given their time, expertise, and financial assistance. I especially thank Margot Ernst, Barbara Foshay-Miller, Joyce and George Moss, Patricia Orden, Barbara Pine, and Barbara Wise. The assistance of colleagues at The Japan Foundation and the Canadian Consulate in New York has also been greatly appreciated.

The artists' dealers and their staffs were exceptionally helpful: Nicole Klagsbrun, Janelle Reiring and Helen Weiner of Metro Pictures, Jim Cohan of Anthony D'Offay Gallery, Donald Young, and David Zwirner. I also want to thank Susanne Ghez of the Renaissance Society, Yukiko Shikata and Kazunao Abe of Canon ARTLAB, Sherri Geldin and Bill Horrigan of the Wexner Center for the Visual Arts, Edith Kramer of the Pacific film Archive, James Quandt of the Cinemathèque Ontario, Carlota Alvarez Basso of the Museo Nacional Centro de Arte Reina Sofía, Rolf Lauter of the Museum für Moderne Kunst (Frankfurt-am-Main), Kira Perov and Dianna Pescar of Bill Viola Studios, and Lori Zippay and Stephen Vitiello of Electronic Arts Intermix. For their input of various kinds, I want to recognize Paola Antonelli, Deirdre Boyle, Sheryl Conkelton, John Coplans, Peggy Gale, Mona Hatoum, Ralph Hocking, Mary Milton, Nam June Paik, Tom Wolf, and Henry Zemel.

A collegial team within the Museum has made *Video Spaces* possible. Sally Berger, working with the Video Program's committed group of interns, perceptively and efficiently oversaw myriad details, including the compilation of biographical material for the catalogue. Daniel Vecchitto and John L. Wielk helped secure funding for the exhibition. James S. Snyder and Eleni Cocordas coordinated complex logistics, and Jerome Neuner devised the innovative installation design, which was carried out by Peter Omlor and the exhibition production staff. Projectionist Charles Kalinowski capably guided us through the complex technical aspects of the individual installations. Nancy Henriksson of the Registrar's office oversaw shipping arrangements, and Elizabeth Tweedy Streibert brilliantly conceived the tour. I appreciate the assistance of Daniel Starr and Eumie Imm, of the Museum Library, and of Jessica Schwartz and Samantha Graham, who have enthusiastically publicized the exhibition.

The Department of Publications was responsible for the production of the catalogue; I want to thank Osa Brown, Nancy Kranz, and Harriet Schoenholz Bee, as well as editors Alexandra Bonfante-Warren and Barbara Ross Geiger for their clarity, and Marc Sapir for skillfully finding "electronic" solutions to the production process. For the innovative book design, I am indebted to Tony Drobinski, who once again rose to the challenge of portraying video art on the printed page; to Devika Khanna; and to Jody Hanson, who supervised the design of both the catalogue and the installation graphics.

I particularly want to thank Richard E. Oldenburg, Director Emeritus; Glenn D. Lowry, Director Designate; Mary Lea Bandy and Laurence Kardish, of the Department of Film and Video; Kirk Varnedoe and Robert Storr, of the Department of Painting and Sculpture; and Riva Castleman, of the Department of Prints and Illustrated Books. Their dedication to this project transformed an idea into reality.

—B.L.

Introduction

by Samuel R. Delany

I began reading science fiction well back in elementary school, toward the start of the 1950s. An experience I connect with that early reading is a visit to The Museum of Modern art in the seventh or eighth grade. The piece in the Museum that struck me most forcefully as a child (a child who had been reading science fiction stories for a year or two) was Thomas Wilfred's *Vertical Sequence, Op. 137* (1941), one of a series of works he called Lumia compositions.

Vertical Sequence stood in the middle of one of the side galleries—a small box, on one side of which was a translucent glass screen. On this surface, propelled by hidden mirrors, lenses, lights, and mechanical motors within the box, colors swirled, drifted, vanished, and reappeared in syrupy, attenuated slow motion. *Vertical Sequence* was the piece I and my classmates talked about after we left the Museum, the piece we urged all our friends to see. It wasn't quite a painting. It didn't hang on a wall. Though it stood free in the center of a room, it wasn't a sculpture: the part you paid attention to comprised images on a flat surface. For a long time *Vertical Sequence* had its own small, darkened gallery—like a contemporary installation. Although clearly the movement on the screen was created by mechanical means (if you put your ear against it, you could just make out the *whirrr* of rotors), rather than electronic circuitry, it seemed—at least to the child's eye—to have something to do with television, which had only recently become widely available.

Science fiction has always come to us in two forms. The first and more significant is the written form, which ranges from the swashbuckling adventures of "Doc" Smith and the semiliterate Colonel S. P. Meek, to the sophisticated and verbally rich work of Stanley G. Weinbaum,

Cordwainer Smith, Alfred Bester, Theodore Sturgeon, Joanna Russ, and Thomas M. Disch. Second is the visual form—commercial comics and films—in which any concern for clear observation of the world is lost to the overwhelming fear of placing any intellectual strain on the audience. From time to time the visual form does produce an interesting surface—for example, in comic-book illustrator Alex Raymond's Flash Gordon series, or in filmmaker George Lucas's Star Wars trilogy. What keeps this surface from amassing any substantial conceptual weight is its producers' fear of the audience's response should that surface ever display any identifiable ideas.

The popular notions connected with science fiction—the special effects of "sci fi"—come almost entirely from this second form. The worth and significance of the field come entirely from the first, even when the occasional reader, excited by ideas generated by the written form, applies them in interesting ways to some of the visual surfaces produced by the second. It is worth noting, then, that the young people who were excited by *Vertical Sequence* were science fiction *readers,* not viewers. (The real descendants of Wilfred's Lumia compositions are the "light shows" that accompanied rock concerts throughout the 1960s and 1970s. Though many of these are now computerized—and video has certainly made its inroads here as well—most of the effects, like those of *Vertical Sequence,* are still largely created using mechanical means.)

In John Varley's fine science fiction story *The Phantom Kansas* (1976), weather sculptors create marvelous weather "symphonies," using computers, dry ice, and explosions to create tornadoes, lightning bolts, and cloud formations that move back and forth across the sun over the course of a few hours or

even days. In this story of a murder victim brought back to life to seek out her killer, these meteorological progressions are the topic of much critical scrutiny. Thousands of people emerge from indoors to watch them, and experience them when they involve rain and wind. But from J. G. Ballard's *The Cloud Sculptors of Corral-D* (1968), in which pilots sheer away bits of cloud with the wings of their biplanes to create shapes in the sky, to Spider and Jean Robinson's *Stardance* (1977), in which a dance company performs its works in the zero gravity of a space station, science fiction has always seemed to have a fondness for images of new kinds of art.

Well before Varley, however, "theramins" and "color organs" had found their way into the language of science fiction, to whisper of the possibility of new art forms. The personal import of Wilford's piece to me—and, I suspect, to those other science fiction readers who were excited about it—was that in it one could sense a yearning to be looked at *as a new art.*

For many people video *is* the quintessential "new art," and there is a tendency to look at it with the slightly patronizing gaze reserved for the forever young. However, most of the artists represented in *Video Spaces* have been working in the medium for twenty years or more. All have developed rich vocabularies and intricately explored techniques. The newness here is in the event: the assemblage of the work of nine mature and proven artists.

Using video as a generic term for television, it is useful to remember the key Marshall McLuhan devised for understanding our reaction to what flickers and flashes across the tube: "Low resolution, high involvement." Video is ultimately more engaging than film because we are given so much less information. Even the color range is narrower, the hues more muted, than in a projected film. Before color, the range extended from pale to dark gray, without ever hitting a true black, a true white. When looking at a video monitor, your attention is tuned

way up out of necessity, so that nothing is missed.

In many homes the television set dominates the room it occupies, often droning from morning till night, in the same way that the computer—with its all-important monitor—dominates our workspaces. In the earlier days, video and computer artists were comfortable letting their technical apparatuses overwhelm the architectural spaces in which their work appeared, creating an analogue of our lives even as the images and form of that domination critiqued our experience of commercial television and computers.

But whereas the material technology is certainly there, in much of the video art today it is no longer the center of attention the way it once was. While there are still images on glass screens, other images hang in the air or sweep about the walls. And there has been a shift toward content, and content here includes memory and subjectivity, AIDS, and the transience of the body. The old-fashioned formalists we all tend to be in matters aesthetic must constantly develop new ways to talk about such art.

Video puts a particular spin on the perennial question of framing the image. The traditional picture frame doubtless began as a pastiche of, or ironic commentary on, the architectural window or cabinet door frame—to make a painting appear as a view through a window to the outdoors. With video art, that window comes away from the wall, to stand free within an architectural space. It can be suspended in the air, broken into multiple fragments, opened and closed. With the addition of simple mechanisms, it can move about. And when the image leaves the screen to become dispersed in the air, the framing question is again reconfigured.

For most viewers, a human body visible through the video "window" gives one the sense of looking in. (If we are not actually looking into an architectural interior, then we are looking in on a situation that may, indeed, have an outdoor setting.) This is especially true if the body is nude. Conversely, if we see an

animal through the video window, we sense that we are looking out. (Put clothes on the animal, however, such as we find on William Wegman's dogs, and once more we are looking in.) The fluidity of the image and sound, plus the mobility or absence of the frame itself, suggests shifting and mystical *fata morganas,* an imaginary architecture through whose flexing and flickering corridors, closets, and gardens the video experience moves us, as the video window changes and its images shift. But some aesthetic current of our lives always passes through conceptual houses, buildings, cities we can never see—invisible cities that can only be manifested, to whatever ghostly extent, by technology.

Beginning as an accommodation for art that erupted beyond the physical confines ordinarily associated with the picture frame and the pedestal, the video installation collapses the distinction between painting (images presented along a wall) and sculpture (images standing free of those walls and commanding space and air), between interior and exterior, present and future.

Paradoxically, science fiction is rarely about time. And it is almost never about space. It takes both as given, infinitely extendable categories, pictured as almost wholly under human control—and thus almost wholly unproblematic, even invisible. (It is often about what you can find in them—the specifics of history—but that is something else.) What science fiction often is about is scale, and it uses the infinite fields of time and space to reimagine the past as well as the future.[1]

Two characteristics that video shares with much other contemporary art, especially installation art, are a lack of permanence—the "timelessness" that for so long has seemed essential to "serious" art—and movement—that motion in excess of the contained cycles and oscillations of the mobile, the sweep of movement and image that film, video, and certain large-scale mechanisms alone can

provide. When such motion enters the exhibition space, it excludes a certain concept of history as a static moment to be considered, in all its elements, like a dioramic re-creation. We're still learning what concept of history is freed into play by these mobile images. But even as we are learning how to read them, my suspicion is that underlying them is a concept of history far more complex than most of us are used to.

What is valuable about science fiction is not that it predicts new things (thus presumably giving the reader a running head start on the rest of us) but rather that it presents a range of possibilities (the vast majority of which never come about) that exercise and open up the imagination. Consequently, the new things that do appear—whether in art, technology, or in social patterns—are easier for such readers to fit into their existing world views. It gives us vivid, immediate, and luminous images of new or alternate possibilities—and invites us to describe, to assess, to judge, to reexamine, and to interrogate.

So, too, in their installations, the artists of *Video Spaces* use a great variety of technological and aesthetic underpinning, as well as acquired skills and knowledge, to make new images, and new experiences, and to pose new questions. Only an exploration sensitive to the discourse of the times can begin to fix their import—something that can only be suggested by criticism, something that can be experienced only by standing before, and moving about in, the works themselves.

Note

1 I tend to look at science fiction as a more linguistic phenomenon, as a way of making certain sentences make sense and decoding others that would otherwise be ambiguous. For example: "Her world exploded." Read as ordinary fiction, it is a metaphor for a female character's heightened emotional state. Read as science fiction, it could mean that the planet on which she lived blew up.

Video Spaces:
Eight Installations

Video as an art form began in the mid-1960s, when portable video equipment became available in the consumer market. Until that time the medium had been restricted to well-lit television studios, with their heavy, two-inch video apparatus and teams of engineers. Not that users had an easy time with the Portapak. It consisted of a bulky recording deck, battery pack, and cumbersome camera, and the half-inch tape, stored on open reels, was awkward to operate. Still, artists found the Portapak affordable, and the ability to record in ambient light made the medium attractive. They recognized that video was wide open, with promising artistic potential. During the subsequent thirty years the field has expanded to include a variety of forms, most notably single-channel videotapes, video sculptures, and environmental installations. This introduction serves as a historical context for the artists in *Video Spaces,* and highlights their participation in the development of the medium.

In the early days, some artists adopted video as their primary vehicle, while others incorporated it into areas such as sculpture, dance, performance, and Con-

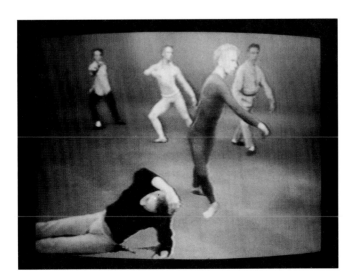

Charles Atlas and Merce Cunningham.
Blue Studio: Five Segments. 1975. Videotape.
Color. Silent. 15 min.

ceptual art. For example, in the droll videotape *John Baldessari Reads Sol LeWitt* (1972), Baldessari faces the camera and in a deadpan voice says, "I'd like to sing for you some of the sentences Sol LeWitt has written on Conceptual art." He begins off-key: "Conceptual artists are mystics rather than rationalists. They leap to conclusions that logic cannot reach." Then, to the tune of "Tea for Two," he continues: "Formal art is essentially rational." The bare-bones presentation and straightforward delivery suggest that the artist felt unconstrained by this new medium.

Richard Serra, already well known for his "process" sculpture, became involved with a group of sculptors and performance artists who were experimenting with video in the early 1970s. In *Surprise Attack* (1973), the sculptor's lower arms appear on the screen. He slams a lead ingot from hand to hand, declaiming a text taken from *The Strategy of Conflict* (1960) by sociologist Thomas C. Schelling. The rhythm of the words becomes more and more emphatic, matching the vehement thrust of Serra's hands. Video's black-and-white imagery, low resolution, and defined space are suited to examining this kind of simple action.

Dancers who worked with video developed specific forms of choreography for the "camera space"—the small area directly in front of the camera. Merce Cunningham, Trisha Brown, and Simone Forti defined the field of view of the monitor, in some cases putting tape on the floor—and in effect, the video frame became a proscenium. The fact that dancers were able to see themselves "live" on a monitor also contributed to the emergence of new kinds of productions. In *Blue Studio* (1975), five Merce Cunninghams perform together as a "corps" in the same space without falling over each other—a dance that can exist only as video.

One of the few artists who has moved fluidly between video and other mediums is Bruce Nauman. Throughout his exten-

sive career Nauman has explored the traditional forms of drawing and sculpture, as well as the twentieth-century mediums of film, holography, video, and installation art. In *Corridor Installation* (1970), he constructed six passageways, three passable and three not. At the end of one cramped corridor were two stacked video monitors showing the empty corridor. As viewers advanced down the narrow space, their backs unexpectedly appeared on one of the screens—the "real time" image on the surveillance monitor contrasted sharply with the stasis of the other screen. The conflation of present and past is a theme that recurs in video in different guises.

The career of one of today's best-known video artists, Nam June Paik, began with a doctored-up series of old television sets that he turned into sculpture. A few years later, in 1965, he obtained one of the first portable video cameras to reach New York. Paik, excited as a child with a new toy, took the camera into his studio, onto the street—in fact, nearly everywhere he went. His recordings, mischievous and exuberant, were showcased at a local artists' hangout, the Café à GoGo. In 1967 Paik's voracious appetite for everything current led him to focus on John Lindsay, then mayor of New York. Paik purloined several moments from a televised press conference in which the mayor said, "As soon as this is over, you may start recording." Viewers were able to lampoon the famous politician by sliding magnets across the top of the monitor, distorting his handsome features. It was early interactive video, for the sometimes playful radicalism of the 1960s.

Paik later converted the black-and-white footage into psychedelically colored videotapes using an "image processor" that he and Shuya Abe soldered together.[1] Paik often assembled his tapes with the fast cutting style typical of television commercials, and in some works with multiple screens he did not coordinate the relationships between images on the various monitors. Here, influenced by the compositional ideas of John Cage,

Paik was seeking a serendipitous juxtaposition of images.

Technical factors initially made it difficult for museums to exhibit video. Reel-to-reel tape decks required someone to thread up, start, and rewind each tape. Video was first presented at The Museum of Modern Art in the 1968 exhibition *The Machine as Seen at the End of the Mechanical Age*. The show was mainly about kinetic art, but it included Paik and many other artists working in electronic mediums. Paik turned his *Lindsay Tape* of 1967 into an installation by rigging an endless-loop device. He set an open-reel, half-inch playback deck on the floor several feet away from a sewing machine bobbin and spool, and ran the spliced tape between them. This loop anticipated the videocassette.

The following year, *TV as a Creative Medium*, the first exhibition in the United States devoted exclusively to video art, was presented at the Howard Wise Gallery in New York. The show emphasized the machinery of video rather than its images. Paik presented several of his television sculptures, and Frank Gillette and Ira Schneider showed *Wipe Cycle* (1969), a work of nine monitors arranged in a grid. This early "video wall" combined both live and delayed coverage of the comings and goings in the gallery, intercut with commercial television programs. In keeping with the contemporaneous influence of Marshall McLuhan, the medium, not the content, was the message.

In the late 1960s, artists such as Woody and Steina Vasulka were seeing what they could coax out of video technology itself. The Vasulkas manipulated the video signal directly, bypassing the camera-recorded world. Their images were based on the wave form of the video signal, modulated by the sound component. Their loft, cluttered with video paraphernalia and secondhand computer components, became a gathering spot where friends showed their new videotapes. Before long, the crowds became too large, and the Vasulkas moved the screenings to the basement kitchen of the Mercer Art Center. When the building collapsed in

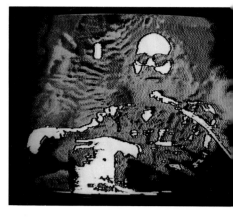

Nam June Paik. *Global Groove*. 1973. Videotape. Color. Stereo sound. 28 min.

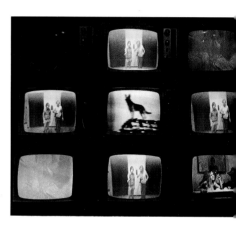

Frank Gillette and Ira Schneider. *Wipe Cycle*. 1969. Video installation. Shown installed in *TV as a Creative Medium*, Howard Wise Gallery, New York, 1969. Collection of the artists

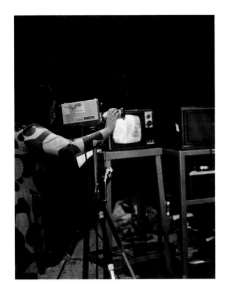

Shigeko Kubota, Video Curator, Anthology Film Archives, New York, at the Archives' first video program, 1976

1973, the Electronic Kitchen moved to Soho, where it flowered as The Kitchen Center for Video, Music, and Dance. Climbing the dark stairway to this lively alternative space, visitors were never too sure what they might encounter: aggressive political activity, the first Women's Video Festival, or the latest breakthrough in video installation or performance art—or some amalgamation of them. Still today, with the proliferation of overlapping art forms, it can be difficult to categorize these artworks.

A number of artists were intrigued by the nature of video as a light-borne medium. Like film, video uses light directly to convey the image. Mary Lucier was inspired to treat this light as a physical material. In live performances at The Kitchen, Lucier aimed her camera at stationary lasers, burning pencil-thin lines into the camera tube. The burned-in traces appeared as scars in subsequent live camera shots of the audience. Bill Viola investigated the transient nature of the light-transmitted image. In *Decay Time* (1974), a strobe intermittently illuminated a dark room. Only for an instant did a camera positioned in the room have enough light to form a likeness of the viewer, which appeared as a life-size projection on the wall. An image was born, flashed before the viewer's eyes, then died in blackness. The representation endured only in the memory of the viewer.

At the Anthology Film Archives, another alternative space in New York, the video sculptor Shigeko Kubota organized a weekly forum where artists gathered to show their works-in-progress. During this formative time, many video works resembled sketches, in that they

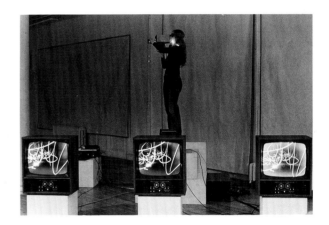

Mary Lucier. *Fire Writing/Video*. Performance at The Kitchen, New York, 1975

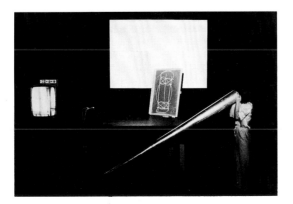

Joan Jonas. *Mirage*. Performance at the Anthology Film Archives, New York, 1976

were stages of problem-solving and focused on single ideas. In one short videotape, Gary Hill gives words tangibility by showing a small speaker vibrating to his spoken text. In another study, abstract forms metamorphose into recognizable shapes as Hill recites a series of double entendres. Joan Jonas's work at this time involved the interaction between live performance and her recorded actions, shown simultaneously on several monitors on stage. Like many other artists, Jonas developed each project as three separate units—a performance, an installation, and a videotape for distribution.

The introduction of the ¾-inch videocassette in the early 1970s made it feasible to exhibit and distribute video to a wide audience. Within a short time, a new museum position—video curator—came into being, when David Ross joined the staff of the Everson Museum of Art in Syracuse. With youthful enthusiasm, Ross promoted video as the art of today and of the future. This theme was echoed at an international exhibition in 1975. Organized by the Institute of Contemporary Art in Philadelphia, *Video Art* surveyed videotapes and video installations from North America, South America, Japan, and Europe. Many museums in North America and Europe subsequently initiated video exhibition programs, and a literature began to form around the work.[2]

In concert with these developments, artists advanced from the production of relatively simple works to projects that were thematically sophisticated. Two classic works raised issues that have remained central to video over the last twenty years. *Present Continuous Past(s)* (1974), an installation by Dan Graham, consisted of two adjacent rooms lined with mirrors. Viewers had endless opportunities to see themselves reflected "now," while simultaneously seeing on a monitor their actions of moments before. The video delay collapsed the past into the present, distorting the normal seriality of events. Space too, was rearranged, rendered discontinuous in this infinity box of mirrors. For *aen* (1974), Peter

Campus used a camera and projector to confront viewers with live images of their faces projected upside-down, directly onto a wall. In the darkened room, the enlarged, high-contrast images provoked viewers to interact with their "portraits." No matter how they turned their heads or changed their facial expressions, they were startled by the blunt, relentless portrayals of themselves. The expressive possibilities of interactivity engendered other imaginative installations involving viewer response. However, today, in the intersecting fields of video and computers, evolving in the form of multimedia, interactivity is at a primitive level where little work has gone beyond button-pushing.

Video, like most human activities, has not escaped the embrace of politics. Participants in the women's movement, which began its current phase at roughly the same time as video, found the medium accessible. With no established bureaucracy or history, video allowed artists to find room and jump right in. On the West Coast, Judith Barry engaged in a theoretically informed feminism, interpreting femininity and masculinity as social constructs based upon race, class, and language. In Barry's *Kaleidoscope* (1979), a series of vignettes about "typical" family life, characters argue feminist theory. One amusing scene depicts a couple—ostensibly a woman and a man—in bed. Before long, viewers realize that these are two women leaning against pillows tacked to a wall, behind bed sheets hung on a clothes line. In a more damning attack on how women are portrayed in the mass media, Dara Birnbaum exposed some of the propaganda techniques of advertising. In *P.M. Magazine* (1982), she appropriated a frame from a familiar television commercial of a pretty secretary seated at a computer and blew it up into a larger-than-life wall panel. The computer-screen image was cut out of the panel and replaced by a real monitor showing female stereotypes in clips from commercials. One sequence featured a cute little girl eating an ice-cream cone, a future woman who, it was hoped, would grow up to a more expansive professional

Peter Campus. *aen*. 1974. Video installation. Shown installed at The Museum of Modern Art, New York, 1976–77. Collection of The Bohen Foundation, New York

world where good looks would not predominate over competence or other values.

The widespread creative activity was coupled with rapid advances in video technology. Nam June Paik's old "image processor" evolved into a sophisticated studio device known as the "Harry," later refined as the "Henry." Frame-accurate video editing became available on ¾-inch tape machines. The glossier work that emerged found support from funding institutions and was frequently shown on public television. Many artists who followed this path later assumed careers in advertising, Hollywood, or with MTV. Other artists showed their work at museums and alternative galleries, and distributed their tapes through newly created, independent associations.

The division between these more-or-less distinct camps was evident in *The Luminous Image,* an exhibition presented at the Stedelijk Museum, Amsterdam, in 1984. The show featured "new music" composer Brian Eno's *Video: Paintings and Sculptures* (1984), a relaxing installation for MTV fans seeking bliss. By contrast, Tony Oursler's assemblage *L7-L5* (1984) explored the periphery of the rational world. In a space ringed by cardboard cutouts of skyscrapers, clips of children playing with "zap" guns, drawings of aliens, and futuristic stories acted out by lurid clay figurines were reflected off

Dara Birnbaum. *P.M. Magazine.* 1982. Mixed-media installation. Shown installed at the Hudson River Museum, Yonkers, New York, 1982. Collection of the artist

tinted water and through broken glass. The work demonstrated a common ground between science fiction, alien visitations, and children's fantasies. Al Robbins, in *Realities 1 to 10 in Electronic Prismings* (1984), focused on a low-tech aspect of video. Viewers had to stumble over cables and other electronic rubble to follow Robbins's daisy-chain of images. Starting with old footage of Cape Cod on a monitor, a camera captured this image and fed it to another monitor. This image in turn was captured by another camera, and so on, until the original recording faded away and became pure light.

One of the first exhibitions to open up a dialogue between still photography and the moving image of film and video was *Passages de l'image* at the Musée National d'Art Moderne, Centre Georges Pompidou, Paris, in 1990. The installation by Chris Marker, although featuring videotapes, had the directness and charm of a family photo album. For years, Marker has carried a camera in order to record his own experiences and the everyday challenges that ordinary people encounter. In *Zapping Zone* (1990), he filled dozens of monitors, arranged in an island in the center of the room, with personal recordings and computer-generated drawings. In Marcel Odenbach's installation, *Die Einen den Anderen (One or the Other)* (1987), images from German opera— which for Odenbach epitomized bourgeois culture and traditional mythologies— were framed in such a way that the viewer became a voyeur, peering through a doorway into the artist's quest for his own history.

In Japan, where craft has traditionally been emphasized over content, video artists have found support largely through commercial organizations. Spiral, a Tokyo complex that comprises a restaurant, gallery, and theater, as well as shops, is a trendy venue for contemporary art and video. In 1990 Spiral sponsored the performance *pH* by the group Dumb Type. *pH* orchestrated electronic equipment and performers in a parody of the regimentation of Japanese society. The set brought to mind the

inside of a giant photocopier, with numerous projected images and large metal frames sweeping across the stage. If performers missed a beat, the frames hit them in the shins or on the head. Teiji Furuhashi, the leader of the group, represented an unfettered spirit by whizzing across the space on a skateboard. Dumb Type's work fluidly incorporates video, computers, dance, and theater. Their performances demonstrate how little remains of the boundaries between art disciplines in the late twentieth century.

The maturity that video as an art form had attained by the early 1990s was evident at the international survey exhibition Documenta IX, in Kassel, Germany, in 1992. Unlike Documenta VII (1977) or Documenta VIII (1984), the numerous video installations here were on an equal footing with painting and sculpture throughout the many pavilions. Video works by artists from Europe, North and South America, and Asia were shown, and included in the main building were installations by Stan Douglas, Gary Hill, Tony Oursler, and Bill Viola.

When the Portapak was introduced to the consumer market, it was impossible to predict to what extent video would be an effective means of artistic expression. Of the artists who explored the medium,

many found it crude and did not persist. Others persevered, though they could never have foreseen the technological advances that in time would enable them to do what they wanted. The novelty appealed to their pioneer spirit, and every enhancement in the camera or tape deck was an occasion for passionate debate and further discovery. Fueled by this energy, video exploded in many different directions. Artists searched for and found the forms most suited to the medium, often in combination with other disciplines. In the process they acquired a technical facility that allowed them to deal with content in sophisticated ways.

In recent years video installation and video sculpture have emerged as the most fertile forms of video art. By releasing the image from a single screen and embedding it in an environment, artists have extended their installations in time and space. The direct connection to another moment and an external location is unique to the video installation. *Video Spaces: Eight Installations* is an international selection of new projects by artists whose primary activity is in environmental video. Their work exhibits a distinctive visual vocabulary and style that exemplifies the current state of video.

Judith Barry/Brad Miskell

A battered wood crate is ready for the garbage pickers. Bold black letters stenciled across its sides identify the crate as having belonged to the Ha®dCell Corporation. Spilling out through missing slats are abandoned computer monitors and keyboards, dusty disk drives, and other high-tech detritus. The contents are webbed together with a nervelike maze of assorted wires and tubing. The computer components and cards twitch and groan, and light flickers on the screens. It is like a cyborg made up of secondhand parts, or an entity from outer space that has just

crash-landed in a dumpster and is crawling out, not quite having gotten all of its pieces back together.

Cyborgs are usually thought of as biological beings modified for life in a non-Earth environment, their organs and appendages replaced by mechanical parts. They are represented as high-tech, sporting a shiny patina. *Ha®dCell* (1994), a rough-and-tumble assemblage antithetical to this conventional image, evokes a curious comparison with an astronaut. This "moonwalker" resembles a cyborg, in that it is a human being within a non-organic outer shell of engineered fabric and tub-

Judith Barry and Brad Miskell. *Ha®dCell*. 1994. Video installation. Shown installed in *Crash: Nostalgia for the Absence of Cyberspace*, Thread Waxing Space, New York, 1994. Produced by, and collection of, the artists

ing. Generally thought of as synonymous with leading-edge technology, the astronaut is actually awkward in its movements, even clumsy. Though the astronaut and its gear may be considered advanced today, in the near future it will look as obsolete as Judith Barry and Brad Miskell's computer components do now.

Like the cyborg, *Ha®dCell* also has fleshy parts. A fragile apparatus—a blue plastic sack that inflates and deflates like a lung—seems to have wriggled out onto the floor. A phallus expands and contracts through a hole in the wood container. These whimsical elements suggest that this is the dawn of the do-it-yourself Heath Kit era of creating living things.

Another kind of assemblage, Dr. Frankenstein's monster, is not at all amusing. In the early nineteenth century, author Mary Shelley was inspired by the work of contemporary scientists, who were then undertaking the first experiments on the human nervous system. In Shelley's story, when the monster comes to life, Dr. Frankenstein is so repulsed by its appearance that he flees the room in terror. Although Shelley refers to tight skin and watery yellow eyes, she is unable to convey what makes the monster so horrific. Yet, at a time when science had just begun tinkering with human biology, she clearly foresaw the fear aroused by what is now known as genetic engineering.

Modern culture has different ways of diminishing the apprehension resulting from biological experimentation and its consequences. Today, television programs present a benign Dr. Frankenstein's monster. Comically rendered, with bolts poking out of his head, he doesn't even frighten children. It is an image that mocks our forebodings, a figure appropriate to an age when people adjust their body parts as readily as they upgrade their computer software.

Disembodied messages and bits of computer code stream across *Ha®dCell*'s computer screens, as if crossed-life forms were communicating with one another: "Mem-shift creates discomfort," "Text indicates viral presences but no antibodies," "I was barely twenty seconds old when I was raped by my father's best friend, an SGI Iridium ^5 with a ferocious hard drive and ten cruel gigs of RAM." At times the text reads as an assemblage of random phrases; at others, as personal narratives. One interchange seems to be occurring between a group of saboteurs and the Ha®dCell Corporation, which is trying to recover stolen materials. This blurring of the mechanical and the human suggests that the computers in *Ha®dCell* have passed the "Turing test." (Initiated by the Boston Computer Museum, this test, named for mathematician Alan Turing, is held annually to determine whether a computer—a "thinking machine"—has progressed to the point where it is indistinguishable from the human brain. No machine has yet passed the Turing test as structured in Boston.)

Postwar American society, living under the threat of nuclear annihilation, was strongly ambivalent about the bounty of new technology. This attitude has changed in recent years, as the public has fallen in love with the personal computer. *Ha®dCell*'s folksy "creature" promotes a sense of ease with technology while cautioning against the current inclination toward an all-out embrace.

Stan Douglas

Once upon a time, watching the evening news was a ritual. The entire family sat down together and looked at television while nibbling frozen dinners. Part of the networks' mandate was to deliver information and to instruct. Having begun their careers in radio, most television newscasters did not see themselves as performers. Edward R. Murrow, for example, believed he had a duty to educate the viewer. Then things changed.

Evening (1994), by Stan Douglas, considers American television of the late 1960s, when the networks became less concerned with the editorial content of their newscasts than with enhancing the stardom of their anchors. Douglas's installation is centered around WCSL, which is based on the station in Chicago that initi-

ated the concept of "happy news," and two other fictional stations in that city, WBMB and WAMQ. The stations are represented by three large video images projected onto individual screens mounted side by side on a long wall. Using archival clips, Douglas follows nine developing news stories from 1969 and 1970. The contemporary footage is in color, while the archival material projected behind the anchors is in black-and-white. The spare set design and rough edits are faithful to the production values of the time.

The news anchors, portrayed by actors, read material scripted by the artist. Beginning in unison with "Good evening, this is the evening news," they proceed with their separate reports. The anchors wear uniform happy faces, no matter how horrifying or inconsequential the events they are covering. Between reports on the trial of the Chicago Seven, the Vietnam War, and the investigation into the murder of local Black Panther Party leader Fred Hampton, the stations' directors cut between human-interest stories and bantering among the newscasters. This was "infotainment" before there was a word for it.

In front of each screen, an umbrella speaker directs the sound from the corresponding track downward. Standing under the WCSL speaker dome, it is easy to keep score politically: Abby Hoffman is a buffoon, Adam Clayton Powell, Jr., is a thief, and the heart transplant surgeon Dr. Christiaan Barnard is a savior. The trial of Lieutenant William L. Calley, Jr., charged in the My Lai massacre, is dismissed as just one of those stories from the 1960s that won't go away.

Moving into the sound space of other "stations," viewers may compare presentations of the same news feature. WBMB's approach to the Calley story is to emphasize the philosophical and public-relations problems that the massacre raised for the American military. In another issued addressed, Congresswoman Shirley Chisholm puts the controversial Black Panthers in perspective, noting that they are not the Communist menace J. Edgar Hoover believes them to be. For the most

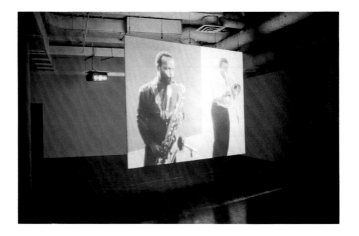

Stan Douglas. *Hors-champs*. 1992. Video installation. Shown installed at the Art Gallery of York University, Toronto, 1992

part, WBMB maintains a more traditional, paternalistic tone, WCSL features "happy talk," and WAMQ falls somewhere between the two. However, all of them soften the coverage of disturbing news by removing the sharp edges.

When viewers stand back some distance from the screens and the speaker pods, the sound becomes indistinct. Key names and words—"J. Edgar Hoover," "radicals," "murderer"—merge in a polyphonic soundscape similar to concrete poetry. When viewed from this distance—both in time and space—the residue, a few vague memories and catchwords, is an appropriate distillation of the pablum that is presented as journalism on television.

Douglas's cool, analytical approach to the media is fundamental to his work. In *Hors-champs* (1992), several African-American musicians who reside in Europe are shown jamming, their recorded sessions projected on both sides of a large, freestanding screen. The installation focuses on the formality and elegance of the presentation rather than on the beat of the music. By taking the music out of its established context—the smoky nightclub—Douglas suggests a new way of thinking about the soul of jazz.

This restraint also informs the way Douglas treats advertisers in *Evening*. He does not castigate them for their pernicious effect on the news—turning it

into a ratings game—but simply denotes commercial time slots with the words "PLACE AD HERE." This minimal statement puts the burden on the viewer to develop the thought. In this understated manner, Douglas expresses the civilized person's yearning for a humane and rational world.

Teiji Furuhashi

"Lover" is a common word, and lovers are a popular subject in art. As an image, a pair of lovers often suggests a castle of exclusion. With the sexual liberation of the last few decades, the word now has more to do with physical coupling than with the sublimity of "true love." AIDS has added a new dimension of wariness to this pairing.

The life-size dancers in Teiji Furuhashi's *Lovers* (1994) are drained of life. Projected onto the black walls of a square room, the naked figures have a spectral quality. Their movements are simple and repetitive. Back and forth, they walk and run and move with animal grace. After a while, their actions become familiar, so that it is a surprise when two of the translucent bodies come together in a virtual embrace. These ostensible lovers—more overlapping than touching—are not physically entwined.

Unlike much contemporary Japanese art, Furuhashi's work has a political edge. With fellow members of Dumb Type, a

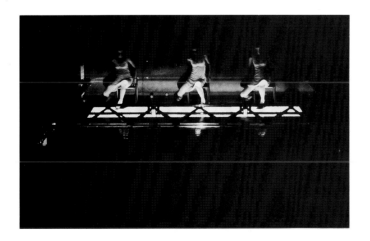

Dumb Type. *pH*. Performance at the Brooklyn Bridge Anchorage, New York, 1991

Kyoto-based performance group, he combines video, performance, music, printed matter, and installation to expand the expressive possibilities of art. Forthright and ironic, the group presents a spirited but ultimately somber view. Their acerbic work directs attention to a society—that of Japan—overloaded with information— yet seemingly relishing its technomania.

Dumb Type's work is beholden to Ankoku Butoh, which is a confrontational form of avant-garde dance in Japan. Meaning the "dance of utter darkness," Butoh dates back to the late 1950s, and is still quite popular. Its creator, Tatsumi Hijikata, searched for something authentic to be fashioned out of Japanese tradition. Thus, Butoh exposes the dark, hidden side that Hijikata felt had been submerged in a contemporary society influenced by European and American culture. Highlighting bad taste, the banal, and the embarrassing, Butoh creates images of a wasteland peopled by naked, spastic bodies whitened with rice powder. Like the grimacing ghosts found in Noh theater, Butoh exists in a netherworld between reality and illusion. While today Butoh has lost its relevance, Dumb Type's approach has become more pertinent in challenging the diminished humanity of the information age.

Lovers has a two-part soundscape. When the running figures stop and pause, the air is filled with whispered, indistinguishable phrases, as if a murmuring audience has clustered somewhere in the distance, their voices hushed in awe of the event they are witnessing. A series of metallic "tings" in the aural foreground resembles the bleeps of hospital diagnostic machines. The overall impression is one of tentativeness—possibly hopeful, but perhaps not.

In contrast to the ethereal sounds, words of admonition float across the black walls: "Love is everywhere," "Fear," "Don't fuck with me, fella, use your imagination," "Do not cross this line or jump over." The slowly revolving phrases strike with the power of graffiti, connecting the work to everyday life. At the same time, a gold vertical line, scaled to the human

body, moves toward a horizontal line approaching from the opposite direction. They merge briefly, to resemble the cross hairs of a weapon's sight. From facing walls, projections of the word "limit" stream toward each other, self-consciously couple, then separate. This echoes the movements of the two lovers, who at other times briefly overlap.

A touching moment of *Lovers* occurs when the installation is not crowded. One of the videotaped figures—Furuhashi—stops and seeks out a lone viewer. He pauses and faces this person with arms outstretched. The gesture is not a beckoning one; rather, the artist is assuming a beatific pose. He appears vulnerable and exposed. Then, as if on a precipice, he falls backward into the unknown, accepting his fate. In reaching out to a single viewer in a direct, personal manner, Furuhashi belies the notion that the human spirit must necessarily be overwhelmed by the juggernaut of technology.

Gary Hill

The first time Gary Hill arrived to install *Inasmuch as It Is Always Already Taking Place* (1990) at a museum, he brought close-ups of a body recorded on forty different video loops. He selected sixteen to play on individual rasters—monitors stripped of their outer casings. The rasters, ranging in size from the eyepiece of a camera to the dimensions of an adult rib cage, were set on a shelf recessed five feet into the wall, slightly below eye level. Hill ran each loop on a screen that matched the size of the particular section of the body recorded on the tape. As he positioned the monitors, moving them around with the objectivity of a window dresser, it seemed he was actually handling parts of a living body: a soft belly that rose and fell with each breath, a quadrant of a face with a peering eye like that of a bird warily watching an interloper.

The components of the body displayed in *Inasmuch*—Hill's own—are without any apparent distinction. Neither Adonis nor troll, neither fresh nor lined with age, the body, suits the endless loops,

suggesting that it exists outside of time, without past or future.

The arrangement of the rasters does not follow the organization of a human skeleton. Representations of Hill's ear and arched foot lie side by side; tucked modestly behind them is an image of his groin. Within this unassuming configuration, each raster invites meditation. For example, on one screen a rough thumb toys with the corner of a book page. In its repetition, the simple action of lifting and setting down the page functions like a close-up in a movie. Further, by concentrating the viewer's attention on such a rudimentary activity, the movement, as in a slow-motion replay, takes on the significance of an epic event.

On a torso-size screen, smooth, taut skin stretches over the ridges of bones that shape the human back. The image fills the frame, and the monitor, given its equivalent size, is perceived as part of the body: an enclosure, a vessel, no longer something that simply displays a picture. Raster and image exist as a unified object, as representation, as a living thing.

Long, nervelike black wires attached to each raster are bundled together like spinal chords. Snaked along the shelf, the bundles disappear from view at the back of the recess. Although unifying the system of monitors, this electrical network emphasizes that the body parts are presented as extremities, without a unifying torso. The hidden core to which the components of the body are attached serves as a metaphor for a human being's invisible, existential center: the soul.

Although none of its segments are "still," the installation has the quality of a still life. Typically, the objects in still-life paintings are drawn from everyday life—food and drink, musical instruments, a pipe and tobacco. Their placement appears arbitrary, and they do not communicate with each other. Often set out on a platform or table, the elements are positioned within arm's reach and appeal to all the senses, especially to touch and taste. *Inasmuch* has most in common with a *vanitas,* a category of still life in which the depicted objects are

meant to be reminders of the transience of life. In place of the usual skull and extinguished candle, *Inasmuch* depicts an animate being whose vulnerability underscores the mortality of flesh.

A textured composition of ambient sounds forms an integral part of the installation. For example, the sound of skin being scratched or a tongue clicking inside the mouth, though barely recognizable as such, is orchestrated with recordings of rippling water and softly spoken phrases. Within this uniform soundscape, the looping of the soundtrack combines distinctive notes in a pulse that reinforces the living quality of the installation.

In *Inasmuch* Hill has reduced the requisites for "living" to visceral sounds and, more importantly, physical movement that has no end. However, the ceaseless activity is an illusion, in that each component exists only as a seamless loop of five to thirty seconds in duration. Creating such a loop—one that seems to go on for eternity—involves a bit of a trick: The videotaped image has to match exactly, in position and in movement, at two places on the tape. The segment between these two shots is cut, and the tape spliced into a loop without a discernible beginning or end. Otherwise, for example, if the thumb were to lift the page and then "jump" back to repeat the action, or if the torso should rise slightly and then abruptly rise again, the piece would become a sort of Sisyphean depiction of endlessly repeated activities.

Inasmuch recalls an age when art was thought to be an illusion, a trick played on the senses. Here, the images are not illusory, but time itself is hidden from the viewer, in the way that segments of time are made to appear limitless. In folding time back on itself, a seemingly simple concept, Hill has fashioned a creature whose humanness poses an existential challenge.

Chris Marker

Chris Marker arrived at a meeting in Paris out of breath, weighted down by heavy canvas satchels slung over his shoulders. These, he explained, contained VHS copies of his favorite classic films, such as Howard Hawks's *Only Angels Have Wings* (1939). He was sending these copies of tapes from his personal video library to cinema-starved friends in Bosnia the next day. Mischievously smiling, Marker noted that they were his own re-edited versions. Rid of what he considers to be tiresome second endings and extraneous scenes, the films are now the way he believes they should be.

This courteous gentleman seems to have creatively reworked his life the way he would edit a film. To begin with, the name of his elusive persona is an Americanized pseudonym. Chris Marker probably was born in 1921 in the outskirts of Paris. He remembers seeing his first movie, a silent one, at the age of seven. He joined the French Resistance in the middle of World War II, then became a paratrooper with the United States Air Force in Germany. He has perpetuated a shadowy existence, and photographs of him are strictly taboo. Always on the go, he easily slips in and out of places incognito, and quietly observes without attracting attention.

Marker's first artistic production dates from 1945, when he began a film on postwar Germany using André Bazin's 16mm film camera. Returning home, he discovered that the lens was broken and out of focus; he then put his film career on hold for nearly a decade. Marker began writing regularly for *L'Esprit*, a Marxist-oriented Catholic journal, and for Bazin's *Cahiers du cinéma*, a vehicle for the emerging French New Wave. He tried his hand at a new journalistic form, producing a series of travelogues that combined impressionistic journalism with still photography, published by Editions du Seuil.

During the 1950s Marker was part of the Left Bank Movement, an informal group that included filmmakers Alain Resnais, Agnès Varda, and Georges Franju. He made a series of polemical documen-

taries with Resnais; *Les Statues meurent aussi* (1950), for example, criticizes the arrogation of African art by Western museums. Marker's sympathies have always been with ordinary people, whose lives he turns into history, as in his film *Le Joli Mai* (1962), in which he solicits the views of Parisians in the aftermath of the Algerian War.

Marker's most influential film, *La Jetée* (1962), reveals the artist's ambivalence toward the past. Set in the ruins of Paris after a hypothetical World War III, the film follows a survivor who is forced to time-travel into both the past and the future. Granted an option by his captors, the protagonist elects to reside in the past, only to realize that to do so is equivalent to choosing death.

The installation *Silent Movie* (1994–95) is a soaring tower of five oversize monitors stacked on top of one another, resembling a vertical filmstrip of five frames. The teetering structure is stabilized by guy-wires. Marker associates the overall shape with the visionary building proposed by Victor and Alexander Vesnin for the Moscow Bureau of the Leningrad newspaper *Pravda* in 1924, and therefore with the early spirit of the Russian Revolution. The black-and-white images on the screens look like clips from the silent-movie era; the subtitles appear genuine but are also fabrications, as are the film posters and glossy pinups tacked to adjacent walls. As viewers ponder the authenticity of the material, they are drawn into Marker's reverie on the past.

Marker used video and a computer to make this work, but he restricted the visual effects to those available to silent film directors. These stylistic elements — which include dissolves, superimpositions, irises, and subtitles—helped define the nascent art of cinema. For early cinematographers, such effects represented the leading edge of technology; today, they are charmingly anachronistic.

Marker is attracted to the challenge of working with a limited visual "palette." His reductivist approach is in keeping with his miniaturized recording and editing apparatus, which his production crew

of one—himself—can handle. He brings the silent film up-to-date by juxtaposing his computer-controlled images on multiple screens. The composition is orchestrated in accordance with Lev Kuleshov's experiments in montage. This Russian filmmaker of the silent era showed that a neutral shot in a film edit is colored by the emotional cast of a contiguous shot.

Many consider the silent era to be the golden age of cinema. The medium had developed many expressive techniques—for instance, in the tonier films, the composition of the screen images was based on well-known paintings. In the early 1930s, many film artists reacted to the advancing technologies by opposing the introduction of sound and color film, because they feared these technical innovations would compromise the artistic integrity of the medium.

And indeed, with the introduction of sound and color a new kind of cinema evolved. However nostalgically bound to the "golden age" Marker is, he has not given up the present. Although the quality of the film image is superior, he appreciates the flexibility of video, and travels everywhere with a tiny Video-8 camera. He can shoot, see the material immediately, reshoot if necessary, then edit at home. Marker notes in a letter:

As happy as I am with the freedom that video gives me, I can't help feeling nostalgic when I encounter a 16mm frame of *Sans soleil* or *AK*—and so much more if I evoke true Technicolor, whose mastery has nothing to do with the false perfection of electronics. . . . So far, I haven't seen any high-def [high-definition video] that matches *The Red Shoes*. . . . That said, I wouldn't for anything in the world go back to 16mm shooting and editing. Such are the contradictions of the human soul.[3]

Marcel Odenbach

The installation *Make a Fist in the Pocket* (1994) displays seven monitors arranged in a row at eye level. Each monitor portrays a particular country—Germany, the United States, France, England, Italy, Czechoslovakia, and Mexico—with news

clips about how the established order dealt with its 1968 revolutionaries. Footage of shouting crowds and beatings is intercut with the famous sequence of the Third Reich's burning of books deemed unsuitable for the master race. In the center of the archival footage shown on each screen is an inset of a hand striking the keys of a typewriter. The staccato cadence of the typing recalls the sound effect that Movietone News used to give an urgent pulse to war dispatches in the 1940s.

A large color video projection occupies the opposite wall. For the most part it is a travelogue, shot with a hand-held camera, of Odenbach's recent journeys in Thailand. The huge, grainy images are sensual and current, in sharp contrast to the artist's composite memories of his youth, as shown on the seven monitors. The smaller, monochromatic images seem distant, as if events that have become history have a diminished reality. They are looped over and over, like a recurring bad dream.

In the conventionally "exotic" images of Thailand, topless prostitutes solicit customers on busy streets, while brightly robed monks chant their calming rhythms. At colorful shrines, the sound of coins dropped into metal vases reverberates like temple bells. Within this panorama, the "West" is present in the person of a naked Caucasian man being walked on, in a form of massage. Intercut with this sunny, languorous footage are disturbing clips of Germany: skinheads throwing stones at foreigners, and Asians and Africans framed in the windows of their burning homes. The Germany Odenbach presents is somber and violent, the polar opposite of warm, ostensibly harmonious Thailand. However, the scene of a Thai kick boxer watching CNN coverage of skinheads on a rampage suggests that Germany's internal affairs may manifest themselves globally in surprising ways.

Odenbach is ambivalent about his cultural history. On the one hand, he feels comfortable with the idealism of the 1960s, a time of clear objectives and identifiable programs that people could rally around. During that period, the inhumanity of Hitler's Germany seemed to be a closed chapter in the country's history. In light of the recent unsettling events in Germany, however, the specter of the past has acquired an oppressive presence. The current revanchism has shocked many segments of the society, and left them uncertain how to react to the situation. The artist expresses this feeling in the installation's title: "To make a fist in the pocket," a common German expression for thwarted anger.

On the wall at the entrance to the installation is a quote from Ingeborg Bachman, an Austrian poet and activist who was influential in the 1960s.[4] In bold letters the text reads: "I am writing with my burnt hand about the nature of fire." In this context, fire becomes emblematic of the organized violence in German history. That history and the artist's search for his place in it are Odenbach's subject matter.

Tony Oursler

At the doorway to *System for Dramatic Feedback* (1994) stands a calico entity, a misshapen video face projected onto its cloth head. Over and over again the little effigy cries, "Oh, no! Oh, no! Oh, no!" The voice is shrill and anxious, as if it were witnessing a harrowing event. The doll's emotional demeanor is poignant, and the state of alarm is archetypal. Viewers can empathize, and thereby experience the trauma. It is an *in extremis* situation, so powerful that it evokes nervous laughter among some spectators. Others simply step back and view the character as a carnival barker, warning them before they proceed.

Inside the installation, on the wall opposite the entrance, is a large black-and-white video projection of an audience. Young faces stare glazedly into the room, as movie trailer music plays softly. Munching popcorn and bathed in cinema's silvery glow, these characters are detached and neutral, waiting silently for something to happen. They are witnesses to the routines of Oursler's creations and to the activity of the viewers within this theatrical space.

Slightly off to one side is a mound of stuffed, life-size rag dolls. Stitched together out of Salvation Army hand-me-downs, each of these homey characters is animated by a small video projection that defines one distinct action. At the top of the heap, a disembodied video hand comes down on the posterior of a bent-over male figure, hitting him with a loud smack. The hand comes down again and again, as if to signify that there is no escape from the memory of the experience. The resounding slap acts like a metronome, punctuating the effigy's piercing cry, and the murmurs of the surrounding figures. From behind the mound, a fat, naked female figure hesitantly lurches forward. She pauses, as if about to do something, then straightens up, only to fall down again. She is trapped in a single psychological state, a character in a rut. In the middle of the mound lies a male figure, a penis protruding from his unzipped pants. It becomes erect, then flaccid, larger and smaller, in an endless cycle without gratification.

At the bottom of Oursler's "mutation pile" lies an atrophied body with a gigantic head that looks as if it fell off a statue. Made of white cloth rather than marble, its distorted video face stares out in anguish from underneath the pile bearing down on it. The figure is androgynous, and, as with all of Oursler's rag dolls, the video projection is indistinct. This enhances the universality of the dolls' emotional states, stimulating the viewer's imagination that much more effectively. Oursler's dolls recall those psychologists give to children in order to allow them to reenact an event and play out their emotions, a therapeutic process through which a frightening experience becomes manageable.

In *System for Dramatic Feedback*, the dolls express their emotions as ritual acts that insinuate themselves into the viewers' fantasies. The sensation is somewhat like that of watching a popular television "cop" series. The archetypal situation shows the good policeman successfully, if violently, dealing with evil, thus assuaging the public's fears. Whereas standard-ized television programs channel viewers through a narrow range of emotions, Oursler's effigies, lifelike and nonthreatening, beckon them into an open-ended world of the imagination, where the mind is freed to assemble its personal fictions.

Bill Viola

Bill Viola is an investigator of the world of illusion and its makeup. He feels close to the visionary William Blake, and identifies with this protean artist's metaphysical travails. The poetry of the Sufi mystic Jalaluddin Rumi is equally important to Viola. Rumi has the simplicity of someone who has realized his spiritual quest. He has "seen the light," to use a universal metaphor for enlightenment. Viola molds video images, carried by light, into luminous metaphors of his own.

In the center of *Slowly Turning Narrative* (1992) is a twelve-foot wall panel rapidly rotating on its vertical axis. One side is mirrored, the other is a film screen. Projected onto the revolving wall in black-and-white, an immense visage stares fixedly—a tired face, gazing inward.

Projected onto the same revolving wall from the opposite side of the room, a series of colored images—a carnival at night, children playing with fireworks,

Bill Viola. *The Passing*. 1991. Videotape. Black-and-white. Mono sound. 54 min.

and an empty suburban mall—are intercut with family scenes and pastoral landscapes. The rotating wall, with the face projected on one side and what might be called mind-images on the other, presents an obvious duality: the surface reality of a person, and behind it, the interior experience. The overall impression is of a slowly turning mind absorbed with itself.

When the projection of the man's face falls onto the matte screen, it appears in a normal, almost photographic manner. However, when the other images are projected onto the screen, they are fringed with red, green, and blue, blurred like clouded thoughts. Only at one moment, when the broad surface of the wall is exactly perpendicular to the projection, does the scene briefly come into registration. It is as if a veil has been lifted and the vision has become clear. Viola is here referring to the mystic's task, which in spiritual practice is termed "polishing the mirror."

As the wall rotates and the mind-images fall onto the mirror, they break into shards of light and splatter onto the walls of the room. The mind has exploded.

When the facial image is in turn projected onto the mirror, it also shatters and is strewn around the room. The fragments of the face and the fragments of the mind dematerialize. The distinction between outside appearance and inner reality has dissolved.

The work is like a diptych, with one of the panels—the mirror—adding an extra dimension. Viewers see themselves reflected in the glass as clear, still figures. They are frozen in a carnivalesque world of illusion, where the man's face and mind are a vortex of image fragments. His identity engulfs the viewer; their identities entwine. In this sea of ambiguity, the only certainties are that the wall will keep turning, and that the mirror will always come around again.

An important characteristic of Viola's installations is the existence of an ideal viewing location. *Slowly Turning Narrative* is unique in that the "best place" to stand is inaccessible. It is the pivot on which the wall rotates, at the center of the duality, the unmoving point. In the Tao, it is this point around which the universe revolves.

Notes

1 Called the Paik-Abe Video Synthesizer, the device comprised two cameras, controlled by an electromagnet, that rescanned videotapes playing on monitors. Initially called the "wobbulator," this synthesizer assigned color to the gray scale of black-and-white videotapes and mixed up to seven video inputs.

2 The first museums were: in New York, the Whitney Museum and The Museum of Modern Art; on the West Coast the Long Beach Museum of Art and the Vancouver Art Gallery; in Minneapolis, the Walker Art Center; in Paris, the Musée d'Art Moderne de la Ville de Paris and the Musée National d'Art Moderne, Centre Georges Pompidou; in Amsterdam, the Stedelijk Museum; and in Cologne, the Kölnischer Kunstverein. The programs have since expanded and are now too numerous to list here. For a chronology of early video activity in the United States, see Barbara London with Lorraine Zippay, "A Chronology of Video Activity in the United States: 1965–1980," *Artforum* 9 (September 1980): 42–45; and *Circulating Video Library Catalog* (New York: The Museum of Modern Art, 1983), pp. 41–48.

3 Letter from Chris Marker to the author, October 25, 1994.

4 Bachman died in 1973—in a fire. Odenbach finds encouragement in the recent revival of her work in German universities.

Eight
Installations

H A®D CELL

1994. Five-channel video installation with three projectors, three monitors, three computers, a defibrillator, and miscellaneous materials. Shown installed in *Crash: Nostalgia for the Absence of Cyberspace*, Thread Waxing Space, New York, 1994. Produced by, and collection of, the artists

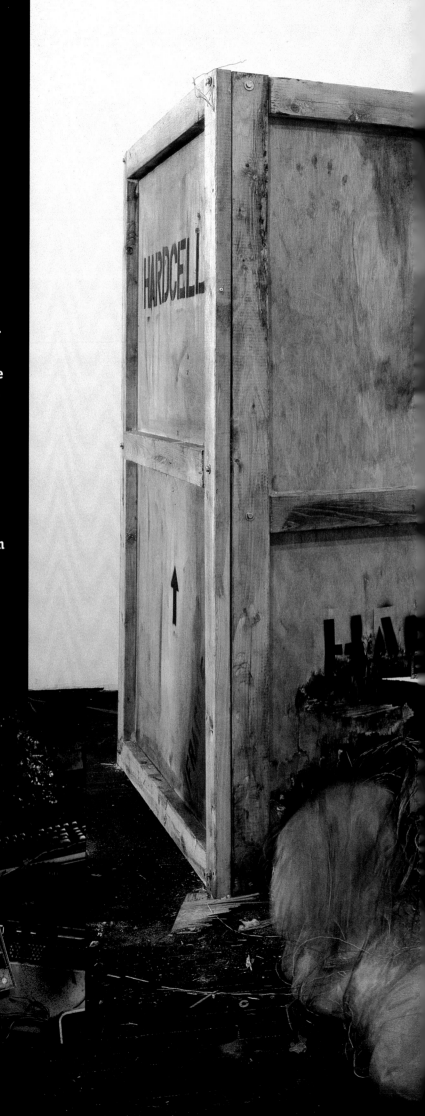

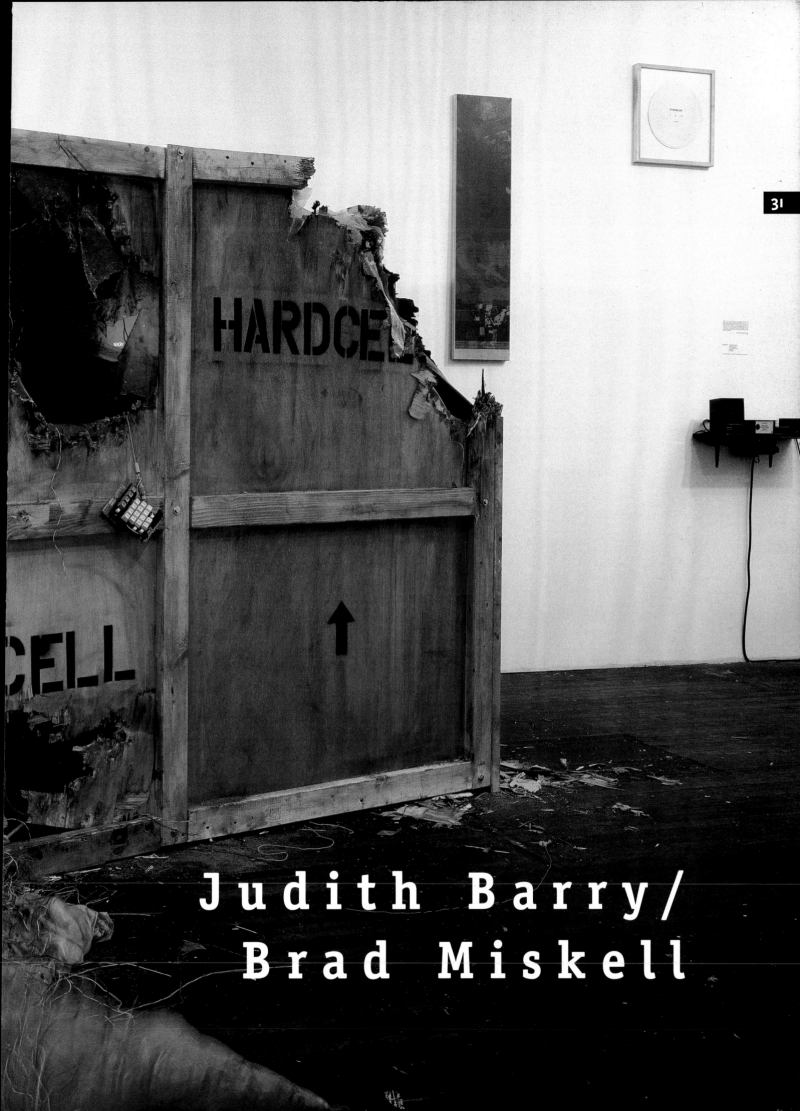

Judith Barry/ Brad Miskell

Kaleidoscope. 1979.
Videotape. Color. Sound.
50 min. Produced
by the San
Francisco Museum
of Modern Art

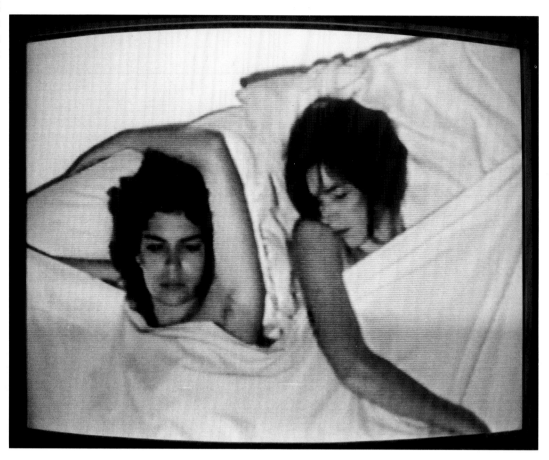

JUDITH BARRY
Selected Solo Exhibitions,
Performances, and Screenings

1977 *Cup/Couch,* La Mamelle Gallery, San
Francisco
PastPresentFutureTense, 80 Langton Street,
San Francisco
1980 *The Dislocated Subject,* Video
Viewpoints, The Museum of Modern Art,
New York
1982 *Ideology/Praxis,* Whitney Museum of
American Art, New York
Space Invaders, International Cultural
Center, Antwerp
1984 *Mass Fantasies/Special Cultures,*
Stichting de Appel, Amsterdam
1986 *Echo,* Projects, The Museum of
Modern Art, New York
In the Shadow of the City . . . vamp r y,
New Langton Arts, San Francisco
1987 *C.O.C.A.,* Natural Foods Pavilion,
Center on Contemporary Art, Seattle
1988 *Echo* and *In the Shadow of the City...*
vamp r y, Douglas Hyde Gallery, Dublin
Loie Fuller: Dance of Colors (performance
with Brigyda Ochaim), Nouvelles Scènes,
Dijon
1989 *Adam's Wish,* Real Art Ways, Hartford
Echo and *In the Shadow of the City . . .*

vamp r y, Galerie Xavier Hufkens, Brussels
Maelstrom: Max Laughs, University Art
Museum, Berkeley
1991 *Imagination, Dead Imagine,* Nicole
Klagsbrun Gallery, New York
In Other Words, Riverside Studios public
video projection, Hammersmith
Underground Station, London
Public Fantasy, Institute of Contemporary
Art, London
1992 *First and Third,* Rena Bransten
Gallery, San Francisco
The Work of the Forest, Stichting de Appel,
Amsterdam; Fondation pour
l'Architecture, Brussels; Musée des
Beaux-Arts, Dunkirk; and Palais Jacques
Coeur, Bourges
1992–93 *Imagination, Dead Imagine* and
Model for Stage and Screen, The Renais-
sance Society at the University of
Chicago; Presentation House, Vancouver
1993 *The Work of the Forest,* MOPT, Madrid
1994 *Geoffrey Beene Unbound* (collabora-
tion with J. Abott Miller), Fashion
Institute of Technology, New York
*Rouen: Intermittent Futures/Touring
Machines,* Institut Européen
d'Aménagement, Convent des Pénitents,
Rouen

Selected Group Exhibitions, Performances, and Screenings

1978 *Global Passport,* San Francisco Museum of Modern Art

1979 *Twelve Artists,* Stichting de Appel, Amsterdam

The Second International Performance Festival, Bologna

1980 *A Decade of Women in Performance Art,* Contemporary Art Center, New Orleans

Video from The Museum of Modern Art, The American Center, Paris

1981 National Video Festival, American Film Institute, John F. Kennedy Center for the Performing Arts, Washington, D.C.

San Francisco International Video Festival

1982 *Godard/Barry, Knight/Graham,* Galerie Rüdiger Schöttle, Munich

Vision in Disbelief, Sydney Biennial

The World Wide Video Festival, Kijkhuis, The Hague

1983 *Scenes and Conventions—Artists' Architecture,* Institute of Contemporary Art, London

1984 *Difference: On Representation and Sexuality,* The New Museum of Contemporary Art, New York

New Voices 4, Allen Memorial Art Museum, Oberlin

Stories of Her Own, Walker Art Center, Minneapolis

1985 *Alles und Noch Viel Mehr,* Kunstmuseum, Bern

The Art of Memory/The Loss of History, The New Museum of Contemporary Art, New York

A Passage Repeated, Long Beach Museum of Art, Long Beach, California

Talking Back to Media, Stichting de Appel, Amsterdam

1986 *Damaged Goods,* The New Museum of Contemporary Art, New York

Dark/Light, Mercer Union, Toronto

Festival des Arts Electroniques, Rennes

1987 *Between Echo and Silence,* Riverside Studios, London

Non in Codice, Galleria Pieroni/American Academy in Rome

This Is Tomorrow Today, The Clocktower, New York (exhibition design)

Whitney Biennial, Whitney Museum of American Art, New York

1988 Aperto '88 (in conjunction with the Venice Biennale)

Biennale de la Danse, Lyons (1988, 1990)

Fatal Strategies, Stux Gallery, New York

The New Urban Landscape, World Financial Center, New York

Impresario: Malcolm McLaren and the British New Wave, The New Museum of Contemporary Art, New York (exhibition design in collaboration with Ken Saylor)

1989 *Forest of Signs,* Museum of Contemporary Art, Los Angeles

Image-World, Whitney Museum of American Art, New York

1990 *La Choix des femmes,* Le Consortium, Dijon

New Works for Different Places, TSWA: Four Cities Project for Derry, Glasgow, Newcastle, and Plymouth, Scotland

The Television Set: From Receiver to Remote Control, The New Museum of Contemporary Art, New York (exhibition design in collaboration with Ken Saylor)

1991 *Ars Memoriae Carnegiensis,* The Carnegie International, Pittsburgh

The Savage Garden, Fundación Caja de Pensiones, Madrid

1992 *A Museum Looks at Itself,* Parrish Art Museum, Southampton, New York

Place, Public, Presentation, Position, Jan Van Eyck Academy, Maastricht

1993 ARTEC '93, Nagoya City Art Museum

Le Génie du lieu, L'Usine Fromage, Rouen

On taking a normal situation and retranslating it into overlapping and multiple readings of conditions past and present, Museum of Contemporary Art, Antwerp

Projet Unité 2, Firminy, France (collaboration with Ken Saylor)

Public Figure, Herron Gallery, Indianapolis Center for Contemporary Art

Seven Rooms, Seven Shows, P.S. 1, Long Island City, New York

The Work of the Forest, Ferme les Buissons, Paris

1994 *Multiple Dimensions,* Belem Cultural Center, Lisbon

Services, Kunstraum der Universität, Lüneburg, Germany

XXII São Paulo Bienal

1995 *Endurance,* Exit Art, New York

Mapping, American Fine Arts, New York

Casual Shopper. 1981.
Videotape. Color. Stereo sound.
Three versions: 3, 6, 28 min. Produced by the University of California, Berkeley

Selected Bibliography

Ardenne, Paul. "Le Génie du lieu," *Art Press,* no. 188 (February 1994).

Barry, Judith. "Artist Project: Tear," *Artforum* 27 (January 1989)

———. "Mappings: A Chronology of Remote Sensing," *Zone: Incorporations* 6 (1992).

———. "Violence in Space," *Violence/ Space, Assemblage* 20 (April 1993).

———. "The Work of the Forest," *Art & Text* 42 (May 1992).

Barry, Judith, and Brad Miskell. "Glossary of Received Ideas," *On taking a normal situation . . .* (Antwerp: Museum of Contemporary Art, 1993).

Brayer, Marie-Ange. "Projects and Projections of Space," *Art Press,* no. 192 (June 1994).

Canogar, Daniel. "Vampires Never Die," *Lapiz,* no. 89 (October 1992).

Gintz, Claude. "Judith Barry," *Forum International* 4 (May–August 1993).

Kaplan, E. Ann. "Feminism(s) Postmodernism(s): MTV and Alternate Women's Videos and Performance Art," *Woman and Performance* 1 (1993).

Morse, Margaret. "The Body in Space," *Art in America* 81 (April 1993).

Public Fantasy: An Anthology of Critical Essays, Fictions and Project Descriptions by Judith Barry, ed. Iwona Blaszwick (London: Institute of Contemporary Art, 1991).

Silver, Kenneth E. "Past Imperfect," *Art in America* 81 (January 1993).

Tallman, Susan. "Judith Barry," *Metropolis* 6 (December 1992).

Vine, Richard. "Pandora's Set," *Art in America* 79 (February 1991).

Wooster, Ann-Sargent. "Wipeout," *Afterimage* (February 1992).

BRAD MISKELL
Selected Performances and Multimedia Collaborations

1978–82 Featured singer/dancer, *The American Dance Machine,* New York, national, and international productions (Lee Theodore, director); *Best of Broadway Dances* (Showtime); *ABC's Omnibus Omni* (ABC); *VIP Night on Broadway,* New York

Featured dancer, *Bad for Good* (Jim Steinman music video; Epic Records)

1983–84 Featured singer/dancer, *Sophisticated Ladies,* first national/inter- national production (Michael Smuin, director)

Featured dancer, *Amahl and the Night Visitors,* Brooklyn Academy of Music (Giancarlo Menotti, director)

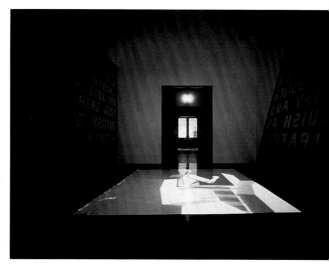

Maelstrom: Max Laughs. 1988. Video installation with projection. Shown installed at the Hayward Gallery, London, 1992. Coproduced by Caesar Video Graphics, New York; the Whitney Museum of American Art, New York; and the artist. Collection of the artist

Principal dancer, *A Chorus Line* (Embassy Pictures; Richard Attenborough, director)

1985–87 Featured actor/singer/dancer, *The Mystery of Edwin Drood,* New York Shakespeare Festival Delacorte Theater and Broadway productions (Wilford Leach, director)

Dancer, *Hysteria* (Def Leppard music video; Mercury Records) and *State Your Mind* (Nile Rodgers music video; Epic Records)

1990–93 Singer/songwriter/producer, Drowned World music/performance group, New York

1992 Codirector/coproducer (with Dan Hubp), *In a Minute* (Drowned World music video)

Collaborations with Judith Barry

1993 Codirectors, *Big Camera* (Drowned World music video)

"Mutate and Grow," soundtrack for *Whole Potatoes from Mashed,* an installation by Judith Barry, in *On taking a normal situation . . . ,* Museum of Contemporary Art, Antwerp

1994 Choreography (with Linda Haberman) for *Geoffrey Beene Unbound,* a video installation by Judith Barry, Fashion Institute of Technology, New York

Fragment 43 (benefit), American Fine Arts, New York

Ha®dCell, in *Crash: Nostalgia for the Absence of Cyberspace,* Thread Waxing Space, New York

1995 Untitled mixed-media installation, in *Re-inventing the Emblem: Contemporary Artists Recreating a Renaissance Idea,* Yale University Art Gallery, New Haven, Connecticut

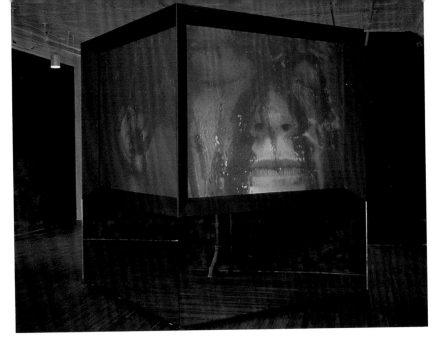

Imagination Dead, Imagine. 1991. Five-channel video installation with projection and sound. Shown installed at the Nicole Klagsbrun Gallery, New York, 1992. Produced by, and collection of, the Centre Cultural, Fundació, Caixa de Pensions, Barcelona

Echo. 1986. Super-8 film, video, slide, and sound installation. Shown installed in the Projects gallery, The Museum of Modern Art, New York, 1986. Produced by The Museum of Modern Art. Collection of the artist

Current Projects

Suburbylon, two-hour pilot created by Brad Miskell and Cat Doran (Paramount Television Group)

Plugged In, documentary series created by Brad Miskell and Cat Doran (Viacom Entertainment)

Selected Bibliography

Miskell, Brad. "Eons...," *Crash: Nostalgia for the Absence of Cyberspace,* eds. Robert Reynolds and Thomas Zummer (New York: Thread Waxing Space, 1994).

———. "The Love Canalchemist: The Abridged Lexicon of Modern Apocryph-ALCHEMY," for *Antwerp(ecidia): A Glossary of Received Ideas,* an installation by Judith Barry, in *On taking a normal situation . . .,* Museum of Contemporary Art, Antwerp, 1993.

———. "Rouen, Capital of the Free World," text for *Rouen: Intermittent Futures/ Touring Machines,* an installation by Judith Barry, in *Le Genie Du Lieu,* Rouen, 1993.

———. "Something Wonderful" and "Dear Concerned Citizen," *Social Text,* no. 36 (Fall 1993).

———. "What I Want," for "(Home)icide," a collaborative text by Judith Barry and Ken Saylor for the installation *House of the Present,* in *Projet Unité 2,* Firminy, France, 1993.

Miskell, Brad, and Judith Barry, "Inquiry into Ha®dCell," *Crash: Nostalgia for the Absence of Cyberspace,* eds. Robert Reynolds and Thomas Zummer (New York: Thread Waxing Space, 1994).

Schneider, Caroline. "Entretien avec Judith Barry: Rouen, Centre du Monde," *Genius Loci* (Rouen: La Difference/Usine Fromage, 1993).

Judith Barry
Born 1954, Columbus
Lives in New York

Brad Miskell
Born 1957, Rocky River, Ohio
Lives in New York

EVENING

1994. Three-channel
video/sound installation
with three projectors.
Color. 20 min. Shown
installed at the Institute
of Contemporary Art, London, 1994.
Produced by the Renaissance Society
at the University of Chicago. Edition
of two. Collection of Dakis Joannou,
and the artist

Stan Douglas

Selected Solo Exhibitions

1983 *Slideworks*, Ridge Theatre, Vancouver

1985 *Panoramic Rotunda*, Or Gallery, Vancouver

1986 *Onomatopoeia*, Western Front, Vancouver

1987 *Perspective '87*, Art Gallery of Ontario, Toronto

1988 *Samuel Beckett: Teleplays*, Vancouver Art Gallery. Traveled in Canada, the United States, Australia, France, and Italy, 1988–91

Television Spots, studies for *Subject to a Film: Marnie*, Contemporary Art Gallery, Vancouver

Television Spots (first six)/Overture, Optica, Montreal

Television Spots (first six), Artspeak Gallery, Vancouver

1989 *Subject to a Film: Marnie/Television Spots*, YYZ Gallery, Toronto

1991 *Monodramas*, Galerie Nationale du Jeu de Paume, Paris

Trois Installations cinématographiques, Canadian Embassy, Paris

1992 *Monodramas*, Art Métropole, Toronto

Monodramas and Loops, University of British Columbia Fine Arts Gallery, Vancouver

1993 *Hors-champs*, Transmission Gallery, Glasgow; World Wide Video Centre, The Hague; David Zwirner Gallery, New York

Monodramas, Christian Nagel Galerie, Cologne

1994 *Hors-champs*, Wadsworth Atheneum, Hartford

Institute of Contemporary Art, London

Kunsthalle Zürich

Musée National d'Art Moderne, Centre Georges Pompidou, Paris

Museo Nacional Centro de Arte Reina Sofía, Madrid

Witte De With, Center for Contemporary Art, Rotterdam

York University and Guelph University, Toronto

1995 The Renaissance Society at the University of Chicago

Selected Group Exhibitions

1983 *PST: Pacific Standard Time* (a YYZ project), Funnel Film Theatre, Toronto; Western Front, Vancouver

Vancouver: Art and Artists 1931–1983, Vancouver Art Gallery

1986 *Broken Muse,* Vancouver Art Gallery

Camera Works, Or Gallery, Vancouver

Mechanics of Memory, Surrey Art Gallery, Surrey, British Columbia

Songs of Experience, National Gallery of Canada, Ottawa

1988 *Behind the Sign*, Artspeak Gallery, Vancouver

Made in Camera, VAVD Editions, Stockholm

Overture. 1986. Film projection with sound. Black-and-white film loop (detail). Loop rotation: 6 min. Produced by the artist. Edition of two. Collection of the Art Gallery of Ontario, Toronto, and the artist

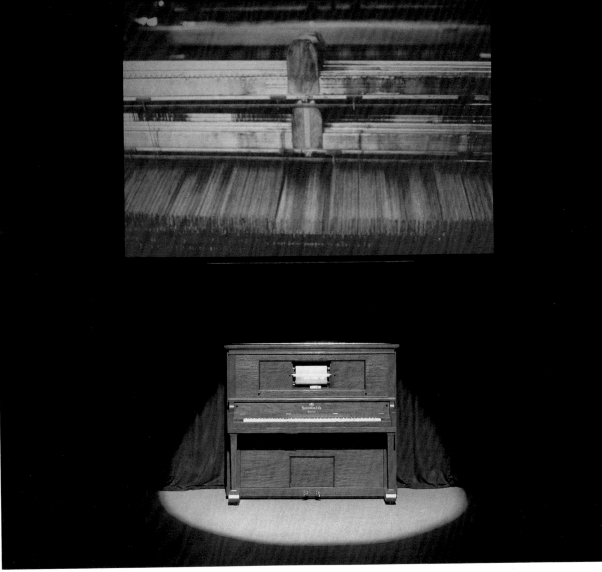

Onomatopoeia.
1985–86.
Slide projection
with player-piano
accompaniment. Black-
and-white. 5 min.
Shown installed at the
Art Gallery of Ontario,
Toronto, 1987. Produced by the
artist. Edition of two.
Collection of the Vancouver Art
Gallery, and the artist

1989 Biennial Exhibition of Contemporary
Canadian Art, National Gallery of Canada,
Ottawa
Photo Kunst, Staatsgalerie Stuttgart
The Vancouver Exchange, Cold City Gallery,
Toronto
1990 Aperto '90 (in conjunction with the
Venice Biennale)
Privé/Public: Art et discours social, Galerie
d'Art Essai et Galerie du Cloître, Rennes
Reenactment, Between Self and Other, The
Power Plant, Toronto
Sydney Biennale, Art Gallery of New South
Wales
1991 *Northern Lights,* Canadian Embassy,
Tokyo
The Projected Image, San Francisco Museum
of Modern Art
Private/Public: Art and Public Discourse,
Winnipeg Art Gallery
*Schwarze Kunst: Konzept zur Politik und
Identität,* Neue Gesellschaft für Bildende
Kunst, Berlin
*Working Truth/Powerful Fiction, Regina
Work Project,* Mackenzie Art Gallery,
Regina, Canada
1992 *The Creation . . . of the African-
Canadian Odyssey,* The Power Plant,
Toronto
Documenta IX, Kassel
1993 *Canada—Une Nouvelle Génération,*
FRAC (Fonds Régionales d'Art
Contemporain) des Pays de la Loire,

Gétigné-Clisson; Musée de l'Abbaye
Sainte-Croix, Les Sables-d'Olonne; Musée
des Beaux-Arts FRAC Franche-Comté,
Dôle, France
Out of Place, Vancouver Art Gallery
Self Winding, Sphere Max, Tokyo; Nanba
City Hall, Osaka
Tele-Aesthetics, Proctor Art Center, Bard
College, Annandale-on-Hudson
Working Drawings, Artspeak Gallery,
Vancouver
1994 *Beeld/Beeld,* Museum van
Hedengaagse Kunst, Ghent
Neither Here nor There, Los Angeles
Contemporary Exhibitions
Stain, Galerie Nicolai Wallner, Copenhagen
1995 *Public Information,* San Francisco
Museum of Modern Art; Museum of
Contemporary Art, Los Angeles; Setagaya
Museum of Art, Tokyo
Whitney Biennial, Whitney Museum of
American Art, New York

Selected Bibliography

Barb, Daniel. "Stan Douglas," *Vanguard* 11
(September 1982).
Bosseur, Jean-Yves. "Le Sonore et le visuel:
Intersections musique/arts plastiques
d'aujourd'hui" (interview), *Paris: Dis Voir*
(1992).
Büchler, Pavel. "Digging it," *Creative
Camera* (October–November 1993).
Cooke, Lynne. "Broadcast Views—Stan

Hors-champs. 1992. Two-channel video projection with sound. Black-and-white. 13 min. Shown installed at the Institute of Contemporary Art, London, 1994. Produced by the Musée National d'Art Moderne, Centre Georges Pompidou, Paris. Edition of two. First edition, collection of the Musée National d'Art Moderne, Centre Georges Pompidou, Paris

Powerhouse Entrance. 1992. Chromogenic print, 21½ × 16". Edition of five. Published by the artist and David Zwirner Gallery, New York

Pursuit, Fear, Catastrophe: Ruskin, B.C. 1993. Film projection with computer-controlled Yamaha Disklavier. Black-and-white. 15 min. Shown installed at the Institute of Contemporary Art, London, 1994. Produced by the artist with support from the Vancouver Art Gallery. Edition of two. Collection of the Vancouver Art Gallery and La Fondation Cartier pour l'Art Contemporain, Paris

Douglas Interviewed by Lynne Cooke," *Frieze,* no. 12 (September 1993).

Culley, Peter. "Dream as Dialectic: Two Works by Stan Douglas," *Vanguard* 16 (September–October 1987).

———. "Window Dressing," *Vanguard* 17 (April–May 1988).

Danzker, Jo-Anne Birnie. "The Beauty of the Weapons," *Canadian Art* 6 (Fall 1989).

Douglas, Stan. "Accompaniment to a Cinematographic Scene: Ruskin, B.C.," *West Coast Line* 26 (Fall 1992).

———. "Goodbye Pork-Pie Hat," *Samuel Beckett: Teleplays*, ed. Stan Douglas (Vancouver: Vancouver Art Gallery, 1988). Reprinted in *Vanguard* 16 (November 1988).

———. "Joanne Tod and the Final Girl," *Joanne Tod* (Toronto: The Power Plant; Saskatoon: Mendel Art Gallery, 1991). Excerpted in *Parachute,* no. 65 (January–March 1991).

———. "Police Daily Record," *Frieze,* no. 12 (September 1993).

———. "Shades of Masochism: Samuel Beckett's Teleplays," *Photofile* (Fall 1990).

———. Introduction, *Vancouver Anthology: The Institutional Politics of Art*, ed. Stan Douglas (Vancouver: Talonbooks, 1991).

Douglas, Stan, with Deanna Ferguson. *Link Fantasy* (Vancouver: Artspeak Gallery, 1988).

Fetherling, Douglas. "Vancouver Anthology," *Canadian Art* 9 (Fall 1992).

Gagnon, Monika. "Reenactment: Between Self and Other," *C Magazine,* no. 26 (Summer 1990).

Gale, Peggy. "Stan Douglas: Perspective '87," *Canadian Art* 5 (Spring 1988).

Harris, Mark. "Stan Douglas: Television Spots," *C Magazine*, no. 21 (Spring 1989).

Henry, Karen. "Television Spots," *Parachute,* no. 51 (June–August 1988).

Hoolbloom, Mike. "Stan Douglas Talks at YYZ," *Independent Eye* 10 (Winter 1989).

Joslit, David. "Projected Identities," *Art in America* 78 (November 1991).

Laing, Carol. "Songs of Experience," *Parachute,* no. 44 (September–November 1986).

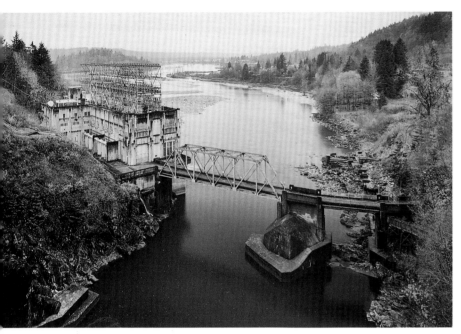

View of the Ruskin Plant and Stave River. 1992. Chromogenic print, 18 × 28". Edition of five. Published by the artist and David Zwirner Gallery, New York

Lawlor, Michael. "Camera Works," *Parachute*, no. 47 (June–August 1987).

Luca, Elisabetta. "Stan Douglas," *Juliet Art Magazine*, no. 64 (October–November 1993).

Nzegwu, Nkiru. "The Creation of the African-Canadian Odyssey," *The International Review of African American Art* 10 (Spring 1992).

O'Brian, John. "Vancouver Anthology," *Parachute*, no. 66 (April–June 1992).

Reveaux, Tony. "Fleeting Phantoms: The Projected Image at SFMoMA," *Artweek*, March 28, 1991.

Rhodes, Richard. "Documenta IX," *Canadian Art* 9 (Fall 1992).

Royoux, Jean Christophe. "Documenta IX: The Call of the Phrase," *Galeries*, no. 50 (August–September 1992).

———. "Resonance: Stan Douglas and Olivier Cadiot," *Galeries*, no. 58 (February–March 1994).

Rudolfs, Harry. "Douglas Loops and Splits in Guelph and Downsview," *Excalibur*, March 16, 1994.

Stals, José Levrero. "Global Art," *Flash Art* 27 (Summer 1994).

Tourangeau, Jean. "Sins of Experience," *Vanguard* 15 (December 1986–January 1987).

Verjee, Zainub. "Vancouver Anthology," *Front* (January–February 1991).

Watson, Scott. "The Afterlife of Interiority: Panoramic Rotunda," *C Magazine*, no. 6 (Summer 1985).

———. "Zweimal Canada Dry—Sechs Künstler aus Vancouver," *Wolkenkratzer Art Journal* 2 (March–April 1988).

Wood, William. "Skinjobs," *C Magazine*, no. 11 (Fall 1986).

Young, Jane. "Broken Muse," *C Magazine*, no. 13 (Spring 1987).

Zazlove, Arne. "Samuel Beckett's Teleplays," *C Magazine*, no. 23 (Fall 1989).

Stan Douglas
Born 1960, Vancouver
Lives in Vancouver

LOVERS

1994. Computer-controlled, five-channel laserdisk/sound installation with five projectors, two sound systems, and slides. Shown installed at Hillside Plaza, Tokyo, 1994. Coproduced with Canon ARTLAB, Tokyo. Collection of the artist

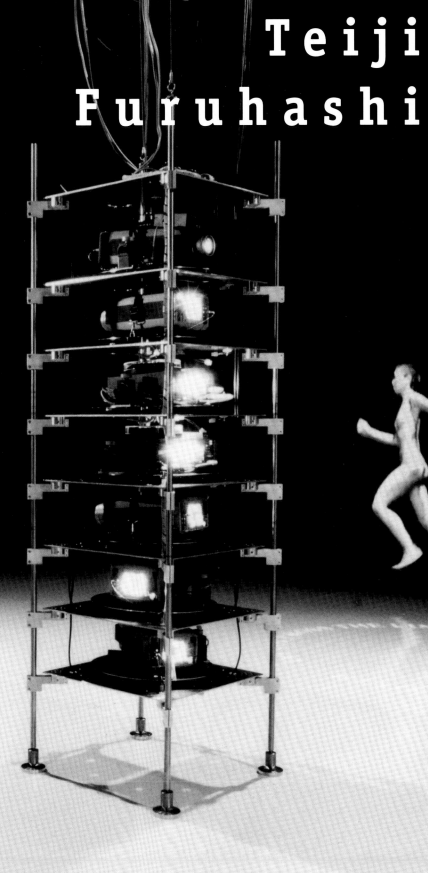

Teiji Furuhashi

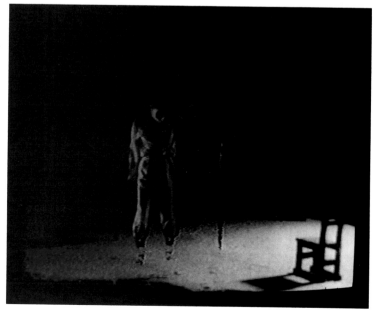

S/N. Performance
with video and
slide projection.
At Adelaide
Festival Space Theater, 1994.
Produced by Dumb Type

Teiji Furuhashi.
*7 Conversation
Styles*. 1984.
Videotape. Color.
Sound. 18 min.

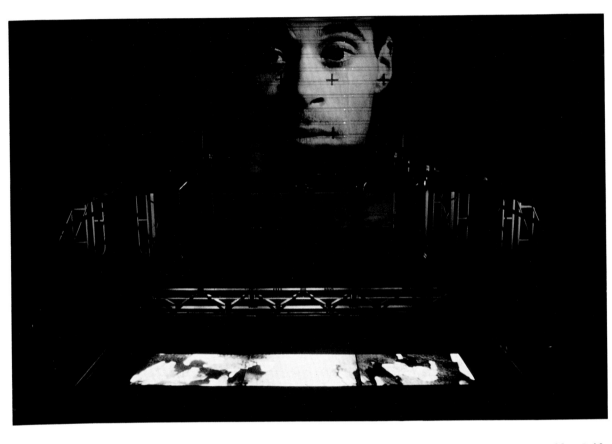

pH. **Performance with video/film projection, slides, sound, and computer-controlled mechanized parts. At Brooklyn Bridge Anchorage, New York, 1991. Produced by Dumb Type and Wacoal Art Center, Tokyo**

In 1984, Furuhashi cofounded Dumb Type, a performance group working with electronic media. Members include architects, videomakers, performance artists, composers, and computer programmers. In addition to Furuhashi, current members of Dumb Type include Takayuki Fujimoto, Peter Golightly, Kenjiro Ishibashi, Izumi Kagita, Toru Koyamada, Noriko Sunayama, Tadasu Takamine, Shiro Takatani, Yoko Takatani, Mayumi Tanaka, Tomohiro Ueshiba, Misako Yabuuchi, Koji Yamada, and Toru Yamanaka.

**DUMB TYPE:
Selected Works**

c: concert; **i**: installation; **p**: performance; **pm**: printed matter; **s**: symposium; **t**: talk; **v**: video

1984 *The Admirable Health Method* (p), Kyoto University of Arts
An Asteroid Addition (p), Kyoto University of Arts
Plan for Sleep #1 (p), Kyoto University of Arts

Plan for Sleep #2 (p), Artspace Mumonkan, Kyoto
1985 *An Encyclopedia for Landscapemanias* (p), Kyoto University of Arts
Every Dog Has His Day (p), Artspace Mumonkan, Kyoto
Listening Hour #1 (p/i/v), Gallery Garden, Kyoto
Listening Hour #2 (p), Museum of Modern Art, Shiga
The Order of the Square (i), ten locations in Kyoto
1986 *Plan for Sleep #3* (p), Orange Room, Osaka
Plan for Sleep #5 (i/pm/s), Osaka International Arts Festival
Plan for Sleep #8 (i/pm/s), Ryo Gallery, Kyoto
1987 *Suspense and Romance* (i/c), Tsukashin Hall, Osaka
Yes, the Salt of Passion—Part 6 (p/i), Toga International Arts Festival (with the performance group Hotel Pro Forma)
036—Pleasure Life (p/v/pm), Artspace Mumonkan, Kyoto
1988 *Pleasure Life* (p), Quest Hall, Tokyo; The First New York International Festival of the Arts, Performance Space 122, New York; Theatre im Pumpenhaus, Münster; Institute of Contemporary Art, London;

The Royal Museum of Fine Arts,
Copenhagen; Kyoto Fumin Hall (ALTI)
1989 *Media Art Museum,* Quest Hall,
Tokyo. Broadcast by TV-NHK, Japan
The Nutcracker (p), Aoyama Round Theater,
Tokyo (with Mika Kurosawa)
Play Back (i/v), in *Against Nature,* San
Francisco Museum of Modern Art.
Traveled internationally, 1989–91
The Polygonal Journey #1 (p), Artspace
Mumonkan, Kyoto (with The Bridgehouse
Collection)
1990 *pH* (p/i/v/pm), Spiral Hall, Tokyo;
Artspace Mumonkan, Kyoto
The Polygonal Journey #2 (p/i), Northern
Light Planetarium, Tromsø, Norway (with
The Bridgehouse Collection)
1991 *pH* (p/i/v/pm), Kyoto Municipal
Museum of the Arts; Institute of
Contemporary Art, Nagoya; Granada
Festival; Art in the Anchorage, New York;
MODA Hall, Osaka; Chapter, Cardiff;
Tramway, Glasgow
1992 *The Enigma of the Late Afternoon* (p).
Commissioned by Glyptotek Museum,
Copenhagen (with Hotel Pro Forma)
pH (p/i/v/pm), in *Zones of Love,*
Messepalast, Vienna Festival; Museo
Nacional Centro de Arte Reina Sofia,
Madrid; Theatre im Pumpenhaus,
Münster; Museum of Contemporary Art,
Sydney

S/N #1 (i), in *The Binary Era: New
Interactions,* Musée d'Ixelles, Brussels
S/N #2 (i), in *Another World,* Art Tower,
Mito Contemporary Art Gallery
1993 *pH* (p), Spiral Hall, Tokyo;
Theaterhaus Gessnerallee, Junefestival,
Zurich
pH (v), Video, Film, Dance Festival,
Ljubljana. Broadcast by RTBF-Liège/Carre
Noir
The Seminar Show for "S/N" (p/t),
Artspace Mumonkan, Kyoto; Shonandai
Culture Center, Civic Theater, Fujisawa
S/N #1 (i), Fukui International Video
Biennale
1994 *LOVE/SEX/DEATH/MONEY/LIFE* (i),
Spiral, Tokyo
Lovers (i), Hillside Plaza, Tokyo
pH (v), Video Film Dance Festival, Hong
Kong
S/N #1 (i), in *Japanese Art after 1945:
Scream Against the Sky,* Yokohama Art
Museum; The Solomon R. Guggenheim
Museum/SoHo, New York. Traveled to the
Yerba Buena Center for Arts, San
Francisco, 1995
S/N (p), Adelaide Festival; Musee d'Art
Contemporain de Montréal; King
Performance Center (On the Board),
Seattle; Land Mark Hall, Yokohama
1995 *SIGNAL/NOISE* (music CD)
S/N (p), Spiral Hall, Tokyo. European tour

Selected Bibliography

Against Nature: Japanese Art in the Eighties (New York: Grey Art Gallery and Study Center/New York University; MIT List Visual Arts Center; The Japan Foundation, 1989).

Binaera: 14 Interaktionen Kunst und Technologie (Vienna: Kunsthalle Wien, 1993).

Dumb Type. *Dumb Type: Recent Works 1987–1991* (Tokyo: Spiral Hall, 1991).

———. *pH: Performance, Exhibition, Printed Matter* (brochure). Tokyo, 1990.

———. *pH-book* (Tokyo: Wacoal Art Center and Dumb Type, 1993).

Durland, Steven. "The Future Is Now— Kyoto's Dumb Type," *High Performance* 13 (Summer 1990).

L'Ere binaire: Nouvelles Interactions (Brussels: Musée Communal d'Ixelles, 1992).

Japanese Art after 1945: Scream Against the Sky, ed. Alexandra Munroe (New York: Harry N. Abrams in association with the Yokohama Museum of Art, The Japan Foundation, The Solomon R. Guggenheim Museum, and the San Francisco Museum of Modern Art, 1994).

London, Barbara. "Electronic Explorations," *Art in America* 80 (May 1992).

Mito Annual '93 Another World 1, 2 (Mito: ATM Contemporary Art Gallery, 1992).

Nakamura, Keiji. "Dumb Type," *Art and Critique* (November 1990).

A Preview of ZONES OF LOVE: Contemporary Art from Japan (Tokyo: Touko Museum of Contemporary Art, 1991).

Zones of Love: Contemporary Art from Japan (Sydney: Museum of Contemporary Art, 1991).

Teiji Furuhashi
Born 1960, Kyoto
Lives in Kyoto

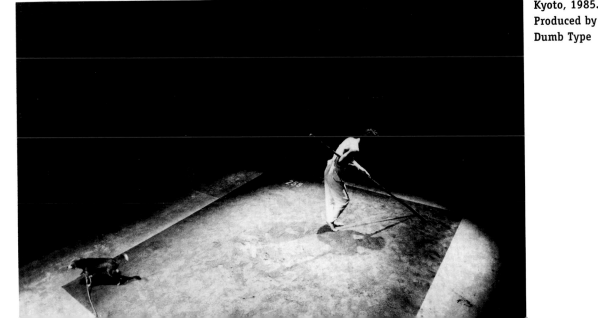

Every Dog Has His Day.
Performance at Artspace Mumonkan, Kyoto, 1985. Produced by Dumb Type

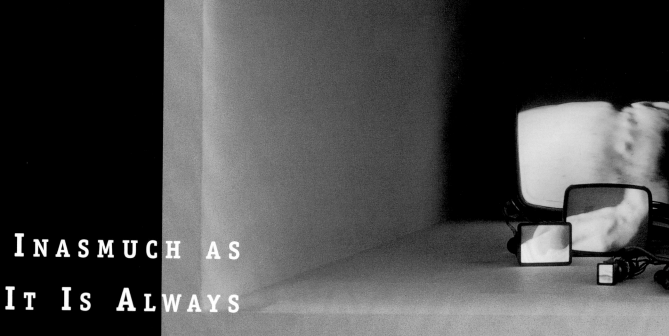

INASMUCH AS
IT IS ALWAYS
ALREADY
TAKING PLACE

1990. Sixteen-channel video/sound installation with sixteen modified monitors recessed in a wall. Shown installed at The Museum of Modern Art, New York. Produced by The Museum of Modern Art and the artist. Collection of the artist

Gary
Hill

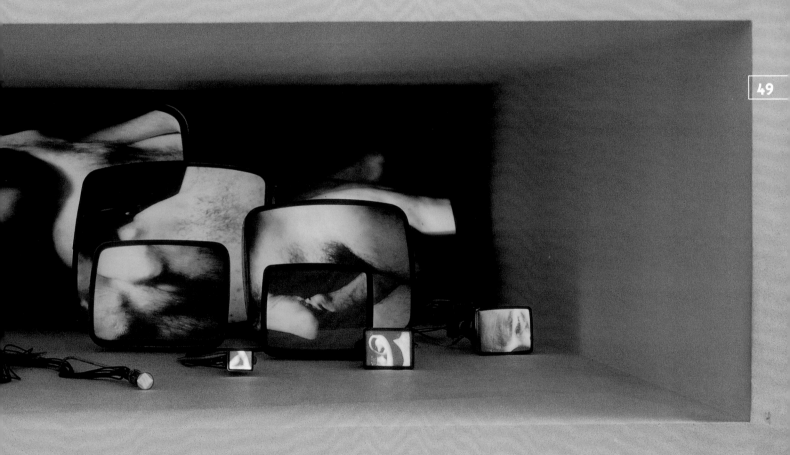

Videograms. 1980–81.
Videotape. Black-
and-white.
Sound.
12 min.

*Happenstance (part
one of many
parts).*
1982–83.
Videotape.
Black-and-
white.
Sound.
6 min.

50

Selected Solo Exhibitions
1971 Polaris Gallery, New York
1974 South Houston Gallery, New York
1976 Anthology Film Archives, New York
1979 The Kitchen, New York
1980 Media Study, Buffalo
Video Viewpoints, The Museum of Modern
Art, New York
1981 And/Or Gallery, Seattle
The Kitchen, New York
1982 *Gary Hill: Equal Time,* Long Beach
Museum of Art, Long Beach, California
1983 The American Center, Paris
International Cultural Center, Antwerp
Whitney Museum of American Art, New
York
1985 Scan Gallery, Tokyo
1986 Whitney Museum of American Art,
New York
1987 Museum of Contemporary Art, Los
Angeles
2ᵉ Semaine Internationale de Vidéo, Saint-
Gervais-Genève
1988 Espace Lyonnais d'Art Contemporain,
Lyons
Video Wochen, Basel
1989 Beursschouburg, Brussels
Kijkhuis, The Hague
Musée d'Art Moderne, Villeneuve d'Ascq
1990 Galerie des Archives, Paris
Galerie Huset/Ny Carlsberg Glyptotek
Museum, Copenhagen
The Museum of Modern Art, New York
1991 Galerie des Archives, Paris
OCO Espace d'Art Contemporain, Paris
1992 *I Believe It Is an Image,* Watari
Museum of Contemporary Art, Tokyo
Stedelijk Van Abbemuseum, Eindhoven
1993 *Gary Hill: In Light of the Other,*
Museum of Modern Art, Oxford
Gary Hill: Sites Recited, Long Beach
Museum of Art, Long Beach, California
1994 *Imagining the Brain Closer than the
Eyes,* Museum für Gegenwartskunst,

Öffentliche Kunstsammlung, Basel
Kunstmuseum, Basel
Traveling exhibition organized by the
 Henry Art Gallery, Seattle, with venues
 in Europe and the United States
1995 Moderna Museet, Stockholm.
 Traveling exhibition organized by
 Riksutställninga, Stockholm, with venues
 throughout Scandinavia.

Selected Group Exhibitions

1972 *Electronic Music Improvisations*
 (performance with Jean-Yves Labat),
 Woodstock Artists' Association,
 Woodstock, New York
1974 *Artists from Upstate New York,* 55
 Mercer Gallery, New York
1975 Projects, The Museum of Modern Art,
 New York
1977 *New Work in Abstract Video Imagery,*
 Everson Museum of Art, Syracuse
1979 *Video: New York State,* The Museum of
 Modern Art, New York
Video Revue, Everson Museum of Art,
 Syracuse
1980 *Video: New York, Seattle, and Los
 Angeles,* The Seibu Museum, Tokyo.
 Traveling exhibition organized by The
 Museum of Modern Art, New York, with
 international venues, 1980–81.
1981 *Projects: Video,* The Museum of
 Modern Art, New York
1982 Sydney Biennial
1983 *The Second Link: Viewpoints on Video
 in the Eighties,* Walter Phillips Gallery,
 Banff
Whitney Biennial, Whitney Museum of
 American Art, New York (1983, 1991,
 1993)
1984 National Video Festival, American
 Film Institute, Los Angeles
Venice Biennale
1985 *Image/Word: The Art of Reading,* New
 Langton Arts, San Francisco
The World Wide Video Festival, Kijkhuis,
 The Hague (1985, 1988)
1986 *Collections vidéos (acquisitions depuis
 1977),* Musée National d'Art Moderne,
 Centre Georges Pompidou, Paris
Cryptic Languages, Washington (D.C.)
 Project for the Arts
Resolution: A Critique of Video Art, Los
 Angeles Contemporary Exhibitions
Video and Language/Video as Language,
 Los Angeles Contemporary Exhibitions
Video: Recent Acquisitions, The Museum of
 Modern Art, New York
1987 *Cinq Pièces avec vue,* Centre Génevois
 de Gravure Contemporaine, Geneva
Contemporary Diptychs: Divided Visions,
 Whitney Museum of American Art, New
 York
Documenta VIII, Kassel
Video Discourse: Mediated Narratives,

La Jolla Museum of Contemporary Art,
 San Diego; Whitney Museum of American
 Art, New York
1988 *Art vidéo americain,* CREDAC, Paris
Degrees of Reality, Long Beach Museum of
 Art, Long Beach, California
1989 *Les Cent Jours d'art contemporain,*
 Centre International d'Art Contemporain
 de Montréal
Delicate Technology, Second Japan Video
 Television Festival, Spiral, Tokyo
Electronic Landscapes, The National Gallery
 of Canada, Ottawa
Eye for I: Video Self-Portraits, Independent
 Curators Incorporated, New York
Video and Language, The Museum of
 Modern Art, New York
*Video-Skulptur: Retrospektiv und aktuell
 1963–1989,* Kölnischer Kunstverein,
 Cologne; Neuer Berliner Kunstverein,
 Kongreßhalle, Berlin; Kunsthaus Zürich
1990 *Energieen,* Stedelijk Museum,
 Amsterdam
Passages de l'image, Musée National d'Art
 Moderne, Centre Georges Pompidou,
 Paris. Traveled in 1991 to the Fundacio
 Caixa de Pensions, Barcelona, and the
 Wexner Center for the Visual Arts, Ohio
 State University, Columbus; and in 1992,
 to the San Francisco Museum of Modern
 Art
1991 ARTEC '91, Nagoya, City Art Museum
Currents, Institute of Contemporary Art,
 Boston
Metropolis, Martin Gropius-Bau, Berlin
Topographie 2: Untergrund, Wiener
 Festwochen, Vienna
1992 *Art at the Armory: Occupied Territory,*
 Museum of Contemporary Art, Chicago

51

*Incidence of
Catastrophe.
1987–88.
Videotape.
Color.
Stereo
sound.
44 min.*

Suspension of Disbelief (for Marine). 1991–92.
Four-channel video installation with thirty modified
monitors and computer-controlled switching matrix.
Shown installed at Le Creux de L'Enfer, Thiers, 1992.
Produced by the Donald Young Gallery, Seattle.
Collection of
the Zentrum für
Kunst und
Medientechnologie,
Karlsruhe

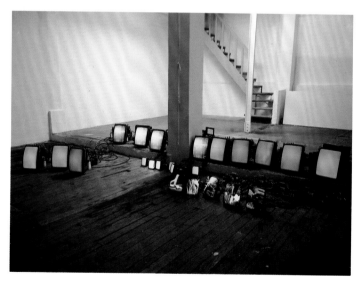

*Between Cinema and a
Hard Place.* 1991.
Three-channel
video/sound installation
with twenty-three
modified monitors and
computer-controlled
switching matrix. Shown installed at the
Galerie des Archives, Paris, 1991. Produced
by Gary Hill. Collection of The Museum of
Modern Art, New York. Gift of
The Bohen Foundation in honor
of Richard E. Oldenburg

The Binary Era: New Interactions, Musée
d'Ixelles, Brussels
Documenta IX, Kassel
*Doubletake: Collective Memory and Current
Art,* Hayward Gallery, London
Japan: Outside/Inside/INbetween, Artists
Space, New York
Manifest, Musée National d'Art Moderne,
Centre Georges Pompidou, Paris
Métamorphose, Saint-Gervais-Genève
Performing Objects, Institute of
Contemporary Art, Boston
1993 *American Art in the 20th Century,*
Royal Academy, London
The Bohen Foundation, New York
*Eadweard Muybridge, Bill Viola, Giulio
Paolini, Gary Hill, James Coleman,* Ydessa
Hendeles Art Foundation, Toronto
Passageworks, Rooseum, Malmö
"Strange" HOTEL, Aarhus Kunstmuseum
The 21st Century, Kunsthalle, Basel
1994 *Cocido y crudo,* Museo Nacional
Centro de Arte Reina Sofía, Madrid
Facts and Figures, Lannan Foundation, Los
Angeles
Multiplas Dimensoes, Centro Cultural de
Belem, Lisbon
São Paulo Bienal
1995 ARS '95 Helsinki, Museum of
Contemporary Art, Helsinki
Identità e alterità, Venice Biennale
Mediale, Zentrum für Kunst und
Medientechnologie, Karlsruhe

Selected Bibliography

van Assche, Christine. "Interview with Gary
Hill," *Galeries,* no. 34 (December
1990–January 1991).
Bellour, Raymond. "La Double Hélice,"
Passages de l'image (Paris: Musée
National d'Art Moderne, Centre Georges
Pompidou, 1990).
Bruce, Chris, Lynne Cooke, Bruce W.
Ferguson, John G. Hanhardt, and Robert
Mittenthal. *Gary Hill* (Seattle: Henry Art
Gallery, University of Washington, 1994).
Cooke, Lynne. "Gary Hill: 'Who am I but a
figure of speech?,'" *Parkett,* no. 34 (1992).
Documenta IX (Stuttgart: Edition Cantz,
1992).

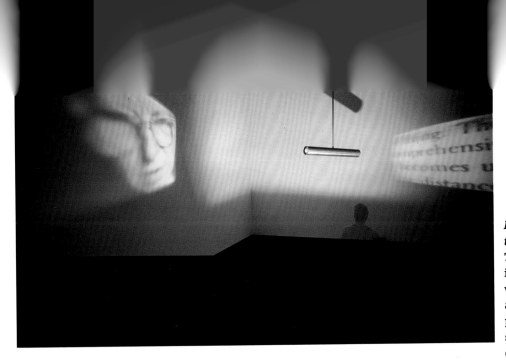

Beacon (Two Versions of the Imaginary). 1990. Two-channel video/sound installation with two television tubes mounted in an aluminum cylinder, projection lenses, four speakers, motor, and controlling electronics. Shown installed at the Stedelijk Museum, Amsterdam, 1990. Produced by, and collection of, the Stedelijk Museum

Eye for I: Video Self-Portraits, trans. Raymond Bellour and Lynne Kirby (New York: Independent Curators Incorporated, 1989).

Furlong, Lucinda. "A Manner of Speaking: An Interview with Gary Hill," *Afterimage,* no. 10 (March 1983).

Hagan, Charles. "Gary Hill, 'Primarily Speaking' at the Whitney Museum of American Art," *Artforum* 22 (February 1984).

Hill, Gary. "And If the Right Hand Did Not Know What the Left Hand Is Doing," *Illuminating Video: An Essential Guide to Video Art,* eds. Doug Hall and Sally Jo Fifer (New York: Aperture; Bay Area Video Coalition, 1990).

———. "Entre-vue," *Gary Hill* (Paris: Musée National d'Arte Moderne, Centre Georges Pompidou, 1992).

———. "Happenstance (explaining it to death)," *Video d'artistes* (Geneva: Bel Vedere, 1986).

———. "Primarily Speaking," *Communications Video,* no. 48 (November 1988).

———. "Site Recite," from "Unspeakable Images," *camera obscura,* no. 24 (1991).

Gary Hill (Amsterdam: Stedelijk Museum; Vienna: Kunsthalle Wien, 1993).

Gary Hill: DISTURBANCE (among the jars) (Villeneuve d'Ascq: Musée d'Art Moderne, 1988). In French and English.

Gary Hill: In Light of the Other, ed. Penelope Curtis (Oxford: Museum of Modern Art; Liverpool: Tate Gallery Liverpool, 1993).

Gary Hill: Más allá de Babel (Valencia: IVAM, 1993).

Gary Hill: Video Installations (Eindhoven: Stedelijk Van Abbemuseum, 1992).

Huici, Fernando. "Gary Hill: Beacon," *Bienal de la Imagen en Movimiento '90* (Madrid: Museo Nacional Centro de Arte Reina Sofía, 1990).

Klonarides, Carole Ann. *Gary Hill—Sites Recited* (Long Beach, Calif.: Long Beach Museum of Art, 1993).

Lageira, Jacinto. "Gary Hill: The Imager of Disaster," *Galeries,* no. 34 (December 1990–January 1991).

———. "Une Verbalisation du regard," *Parachute,* no. 62 (April–June 1991).

London, Barbara. "Between What Is Seen and What Is Heard," *Image Forum,* no. 133 (April 1991).

Phillips, Christopher. "Between Pictures," *Art in America* 79 (November 1991).

Quasha, George. "Notes on the Feedback Horizon," *Glass Onion* (Barrytown, N.Y.: Station Hill Press, 1980).

Sarrazin, Stephen. "Berlin, Metropolis, La Création, Le Désarroi," *Chimaera Monograph 3* (Montbéliard: Edition du Centre International de Création Vidéo Montbéliard Belfort, 1991).

———. "Channeled Silence (Quiet, Something 'is' Thinking)," *Gary Hill—I Believe It Is an Image* (Tokyo: Watari Museum of Contemporary Art, 1992).

Gary Hill
Born 1951, Santa Monica
Lives in Seattle

SILENT MOVIE

1994–95. Five-channel video/sound installation with five 25-inch monitors stacked on metal shelving and steadied with guy wires. Computer-controlled images are accompanied by a separate sound system and photographs. Shown installed at the Wexner Center for the Visual Arts, Ohio State University, Columbus, 1995. Commissioned by the Wexner Center for the Visual Arts, under the auspices of an Artist Residency Award funded by the Wexner Center Foundation. Collection of the artist

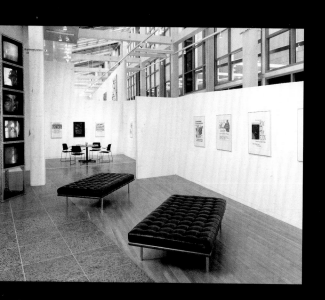

Chris
Marker

Zapping Zone.
1990.
Four-channel
video installation
with thirty moni-
tors. Shown
installed at the

Le Tombeau d'Alexandre. 1993. Video. Color and black-and-white. Sound. 104 min.

La Jetée. 1962. Film. Black-and-white. Sound. 28 min.

Chris Marker
Born c. 1921, near Paris

Selected Films and Videotapes
Films unless otherwise noted.

1952 *Olympia 52.* 82 min.
1956 *Dimanche à Pekin (Sunday in Peking).* 22 min.
1958 *Lettre de Sibérie (Letter from Siberia).* 62 min.
1960 *Description d'un combat (Description of a Struggle).* 60 min.
1961 *Cuba Sí!* 52 min.
1962 *La Jetée.* 28 min.
Le Joli Mai. In two parts: "Prière sur la Tour Eiffel" and "Le Retour de Fantômas." 165 min.
1965 *Le Mystère Koumiko (The Kumiko Mystery).* 54 min.
1966 *Si j'avais quatre dromadaires.* 49 min.
1967 *Loin du Vietnam (Far from Vietnam).* 115 min.
1969 *Le Deuxième Procès d'Artur London.* 28 min.
Jour de tournage (The Confession). 11 min.

Sans Soleil. 1982.
Film. Color. Sound.
110 min.

Loin du
Vietnam.
1967.
Film.
Black-and-
white. Sound. 115 min.

On vous parle du Brésil. 20 min.
1970 *La Bataille des dix millions (The Battle of the Ten Million)*. 58 min.
Carlos Marighela. 17 min.
Les Mots ont un sens (Portrait of François Maspero). 20 min.
1971 *Le Train en marche (The Train Rolls On)* (Portrait of Alexander Medvedkin). 32 min.
1973 *L'Ambassade (The Embassy)*. Super-8 film. 20 min.
1974 *La Solitude du chanteur de fond (The Loneliness of the Long-Distance Singer)* (Portrait of Yves Montand). 60 min.
1977 *Le Fond de l'air est rouge (The Grin Without a Cat)*. In two parts: "Les Mains fragiles (Fragile Hands)" and "Les Mains coupées (Severed Hands)." 240 min.
1981 *Junkopia*. 6 min.
1982 *Sans soleil (Sunless)*. 110 min.
1984 *2084 (One Century of Unionism)*. 10 min.
1985 *AK* (Portrait of Akira Kurosawa). 71 min.
Christo. Videotape. 24 min.
Matta. Videotape. 14 min.
1986 *Eclats*. Videotape. 20 min.
Bestiare. Videotape. 9 min.
Spectre. Videotape. 27 min.

Tarkovsky. Videotape. 26 min.
Tokyo Days. Videotape. 24 min.
1989 *L'Héritage de la chouette (The Owl's Legacy)*. Film transferred to videotape. Thirteen parts, each 26 min.
1990 *Berlin*. Videotape. 17 min.
Berliner Ballade. Produced by Antenne 2. 25 min. (integral version, 29 min.)
Détour Ceaucescu. Videotape. 8 min.
Getting Away with It. Music by Group Electronic. Videotape. 4 min.
Photo Browse. Videotape. 17 min.
Théorie des ensembles (Theory of Sets). Videotape. 11 min.
1992 *Azul Moon*. Videotape. Loop
Coin fenêtre. Videotape. 9 min.
1993 *Slon-Tango*. Videotape. 4 min.
Le Tombeau d'Alexandre (The Last Bolshevik). Videotape. In two parts, each 52 min.
Le 20 Heures dans les camps (Prime Time in the Camps). Videotape. 28 min.
1994 *Bullfight (Okinawa)*. Videotape
Chaika. Videotape. 1 min.
Owl Gets in Your Eyes. Videotape. 1 min.
Petite ceinture. Videotape. 1 min.
1995 *Le Facteur sonne toujours cheval*. Videotape. 52 min.
Immemory. Interactive CD-ROM
Level Eye. 100 min.

Installations

1978 *Quand le Siècle à pris forme, Paris-Berlin*, Musée National d'Art Moderne, Centre Georges Pompidou, Paris
1990 *Zapping Zone*, in *Passages de l'image*, Musée National d'Art Moderne, Centre Georges Pompidou, Paris; Centre Cultural, Fundació, Caixa de Pensions, Barcelona; Wexner Center for the Visual Arts, Ohio State University, Columbus; San Francisco Museum of Modern Art
1994–95 *Silent Movie*, Wexner Center for the Visual Arts, Ohio State University, Columbus; The Museum of Modern Art, New York; University Art Museum, Berkeley

Selected Bibliography

Baker, B. "Chris Marker," *Film Dope* 40 (January 1989).
Bellour, Raymond, Catherine David, Christine van Assche, et al. *Passages de l'image* (Paris: Musée National d'Art Moderne, Centre Georges Pompidou, 1990).
Bensmaia, R. "From the Photogram to the Pictogram: On Chris Marker's *La Jetée*," *camera obscura*, no. 24 (September 1990).
Copjec, J. "Vampires, Breast-Feeding and Anxiety," *October*, no. 58 (Fall 1991).
Gerber, Jacques. *Anatole Dauman, Argos Films: Souvenir-ecran* (Paris: Editions du Centre Pompidou, 1989).

Le Joli Mai.
1962.
Film. Black-
and-white. Sound. 165 min.

Gibson, R. "What Do I Know?: Chris Marker and the Essayist Mode of Cinema," *Filmviews* 32 (Summer 1987).

Graham, Peter, "Cinéma Vérité in France," *Film Quarterly* 17 (Summer 1964).

Hoberman, J. "Japant-Garde Japanorama," *Artforum* 24 (October 1985).

Jacob, Gilles. "Chris Marker and the Mutants," *Sight and Sound* 35 (Autumn 1966).

Levy, J. "Chris Marker: L'Audace et l'honnêteté de la subjectivité," *CinémAction*, no. 41 (January 1987).

Marker, Chris. "AK," *L'Avant-Scène du Cinéma*, no. 403–04 (June–July 1991).

————. *La Chine: Porte ouverte* (Paris: Editions du Seuil, 1956).

————. *Commentaires 1, 2* (Paris: Editions du Seuil, 1961 and 1967).

————. *Coréennes* (Paris: Editions du Seuil, 1959).

————. "Cuba Sí" (script), *L'Avant-Scéne du Cinéma*, no. 6 (1961).

————. *Le Fond de l'air est rouge: Scènes de la troisième guerre mondiale* (Paris: François Maspero, 1976).

————. "A Free Replay (notes sur *Vertigo*)," *Positif*, no. 400 (June 1994).

————. *La Jetée* (New York: Zone Books, 1992).

————. "Sunless," *Oasis* 4 (1984).

————. "Le Tombeau d'Alexandre," *Positif*, no. 391 (September 1993).

————. "William Klein: Painter/ Photographer/Film-maker," *Graphis* 33 (May–June 1978).

Marker, Chris, and Michel Butor. *Le Dépays* (Paris: Editions Herscher, 1982).

Marker, Chris (photos), and Jean-Claude Carrière (text). "Effets et gestes," *Vogue* (Paris), December 1994–January 1995.

Marker, Chris (photos), and Marie Susini (text). *La Renfermée: La Corse* (Paris: Editions du Seuil, 1981).

Rafferty, T. "Chris Marker," *The Thing Happens* (New York: Grove Press, 1993).

————. "Marker Changes Trains," *Sight and Sound* 53 (Autumn 1984).

Roud, Richard. "The Left Bank," *Sight and Sound* 31 (Winter 1962–63).

————. "The Left Bank Revisited," *Sight and Sound* 46 (Summer 1977).

————. "SLON," *Sight and Sound* 42 (Spring 1973).

Silent Movie (Columbus: Wexner Center for the Visual Arts, 1995).

Van Wert, W. F. "Chris Marker: The SLON Films," *Film Quarterly* 32 (Spring 1979).

Walsh, M. "Around the World, Across All Frontiers: *Sans Soleil* and *Dépays*," *C Action* 18 (Fall 1989).

Willmott, G. "Implications for a Sartrean Radical Medium: From Theatre to Cinema," *Discourse* 12 (Spring–Summer 1990).

EINE FAUST IN DER TASCHE MACHEN

(Make a Fist in the Pocket). 1994. Eight-channel video/sound installation with seven 19-inch monitors showing 3-minute programs; a projection of a 7-minute program; and wall text. Shown installed in *Cocido y crudo*, Museo Nacional Centro de Arte Reina Sofía, Madrid, 1994. Produced by the Museo Nacional Centro de Arte Reina Sofía. Collection of the artist

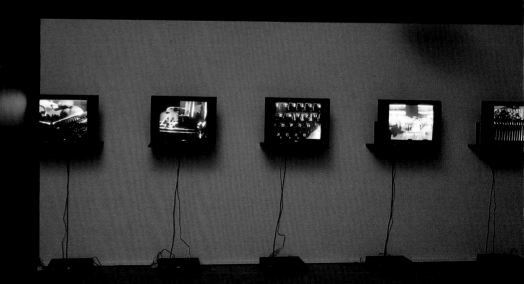

Marcel
Odenbach

Vogel friß oder stirb (Take It or Leave It). 1989. Two-channel video installation. Shown installed at the Musée d'Art Contemporain de Montréal, 1989. Produced by the artist. Edition of two. First edition, collection of the Government of Germany

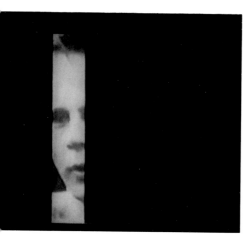

Die Distanz zwischen mir und meinen Verlusten (The Distance Between Myself and My Losses). 1983. Videotape. Color. Sound. 10 min.

Selected Solo Exhibitions

1981 *Marcel Odenbach: Videoarbeiten,* Museum Folkwang, Essen; Städtische Galerie im Lenbachhaus, Munich

Der Konsum meiner eigenen Kritik (The Consumption of My Own Critique), Skulpturenmuseum, Marl

Die Verlorenheit des Spielers (The Player Is Lost [in His Own Game]), Hochschule St. Gallen

Ein Zusammenhang ist da, nicht erklärbar, doch zu erzählen (A Context Is There, Not Explainable, But to Be Told), Galerie Stampa, Basel

1982 *Notwehr oder das arme Tier bekommen (Self-defense or Get the Poor Animals)* and *Ein Zusammenhang ist da, nicht erklärbar, doch zu erzählen,* Stedelijk Museum, Amsterdam

Das Schweigen deutscher Räume erschreckt mich (The Silence of German Rooms Frightens Me), Galerie Magers, Bonn

Tip, tip, tip, was soll dieser Mann sein? (Hint, Hint, Hint, What Is This Man Supposed to Be?), Galerie Rieker, Heilbronn

1985 *Die Einen den Anderen (A,B,C,D) (One or the Other [A,B,C,D]),* Museum van Hedendaagse Kunst, Ghent; Neue Gesellschaft für Bildend Kunst, Berlin; Skulpturenmuseum Marl

Dreihändiges Klavierkonzert für entsetzlich verstimmte Instrumente (Three-handed Piano Concert for Instruments That Are Out of Tune the Same Way), Espace Lyonnaise d'Art Contemporain, Lyons

1986 *Jubelnd lief das Volk durch die Straßen (Rejoicing, The People Ran Through the Streets),* Time Based Arts, Amsterdam

Institute of Contemporary Art, Boston

1987 *Marcel Odenbach: Dans la Vision périphérique du témoin (Marcel Odenbach: In the Peripheral Vision of the Witness),* Musée National d'Art Moderne,

Hey, Man.
1991.
Photo collage
on paper,
56" × 6' 11".
Collection of the artist

Marcel Odenbach: Stehen ist Nichtumfallen, Badischer Kunstverein, Karlsruhe; Städtische Galerie, Erlangen

1989 *Die Einen den Anderen (A,B,C,D),* Galerie Hant, Frankfurt-am-Main

Museo Nacional Centro de Arte Reina Sofía, Madrid

1990 *Frau Holle ein Schnippchen schlagen* and *Vogel friß oder stirb (Take It or Leave It),* Galerie Etienne Ficheroulle, Brussels

Niemand ist mehr dort, wo er hin wollte (Nobody's There Anymore, Where He Wanted to Be), Galerie Ascan Crone, Hamburg; Galerie Elgen-Art, Leipzig

Wenn die Wand an den Tisch rückt (When the Wall Moves to the Table), Galerie Yvon Lambert, Paris; Galerie Eigen-Art, Leipzig

1991 *Auf den fahrenden Zug springen (Jump on a Moving Train),* Galleria Franz Paludetto, Turin

Bellende Hunde beißen nicht (Barking Dogs Don't Bite), Galerie Tanit, Munich

1992 *Vicious Dogs,* Jack Shainman Gallery, New York; Ecole des Beaux-Arts, Bordeaux

1993 *Auf den fahrenden Zug springen; Hals über Kopf (Neck over Head); Safer Video; Vogel friß oder stirb;* and *Niemand ist mehr dort, wo er hin wollte;* Galerie der Stadt Esslingen, Villa Merkel; Braunschweiger Kunstverein, Braunschweig

Hans Guck-in-die-Luft (Jack Look-in-the-Air), Galerie der Stadt Esslingen, Villa Merkel

Mit dem Kopf durch die Wand, Haus der Geschichte der BRD, Bonn (permanent installation)

Marcel Odenbach: Keep in View, Stichting de Appel, Amsterdam

1994 *Lagerbestände (Inventory of Storage),* Galerie Eigen-Art, Leipzig

Tabakkollegium oder mir brennt es unter den Nägeln (Tobacco Committee or It's Urgent to Me), Kunst-und Ausstellungshalle der BRD, Bonn

Selected Group Exhibitions

1978 *Die Grenze,* Neue Galerie, Museum Ludwig, Aachen; Städtisches Kunstmuseum, Bonn; CAPC, Bordeaux

Der Konsum meiner eigenen Kritik, installed in a group exhibition at the Kunstausstellungen Gutenbergstraße, Stuttgart

1979 *Kölner Kunstler persönlich vorgestellt,* Kölnischer Kunstverein, Cologne

1980 *Freunde-Amis,* Rheinisches Landesmuseum, Bonn

Mein Kölner Dom, Kölnischer Kunstverein, Cologne

1981 *10 im Köln,* Kölnischer Kunstverein, Cologne

1982 La Biennale de Paris, ARC, Musée d'Art Moderne de la Ville de Paris

Deutsche Zeichnungen der Gegenwart, Museum Ludwig, Cologne

Videokunst in Deutschland 1963–1982, Kölnischer Kunstverein, Cologne; Badischer Kunstverein, Karlsruhe; Kunsthalle Nürnberg. Traveled in 1983 to the Nationalgalerie, Berlin

1983 *Die Unwahrheit der Venunft,* Galerie ak, Frankfurt-am-Main

1984 *Einblicke: 35 Jahre Kunstförderung,* Palazzo della Societa Pomotrice, Turin

Venice Biennale

The Luminous Image, Stedelijk Museum, Amsterdam

Ping Pong, Galerie Philomine Magers, Bonn

As If Memories Could Deceive Me. 1986. Videotape. Black-and-white and color. Sound. 17 min.

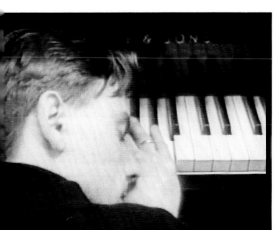

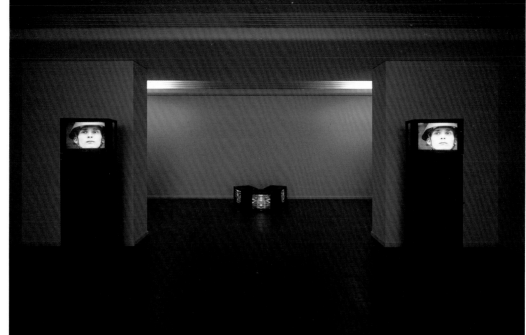

Wenn die Wand an den Tisch rückt (When the Wall Moves to the Table). 1990. Two-channel video installation with text. Shown installed in *Metropolis,* Martin-Gropius-Bau, Berlin, 1991. Produced by the artist. Edition of two. First edition, collection of the Zentrum für Medienkunst Karlsruhe

1985 *By the River 3,* Porin Taldemuseo, Pori
Neuankaufe, Stadisches Kunstmuseum, Düsseldorf
Rheingold, Palazzo della Societa Pomotrice, Turin
Karl Schmidt-Rottluff Stipendium, Austellungshalle Mathildenhöhe, Darmstadt
1986 *Remembrances of Things Past,* Long Beach Museum of Art, Long Beach, California
Videofestival, Circulo de Bellas Artes, Madrid
1987 *The Arts for Television,* Stedelijk Museum, Amsterdam; Museum of Contemporary Art, Los Angeles. Traveled in Europe and North America, 1987–89.
Cinq Pièces avec vue, 2e Semain Internationale de Video, Centre Genévois de Gravure Contemporaine, Geneva
Documenta VIII, Kassel
L'Epoque, la mode, la morale, la passion: Aspects de l'art d'aujourd'hui, Musée National d'Art Moderne, Centre Georges Pompidou, Paris
U-Media, Bildmuseet, Umes, Sweden
1988 *Enchantement/Disturbance,* The Power Plant, Toronto
50 Ateliers internationaux des Pays de la Loire, Abbaye Royale de Fontevraud
Das Gläserne U-Boot, Tabakfabrik Krema, Donaufestival, Stein-am-Rhein, Switzerland
Kölner Kunst, Kunstforeningen, Copenhagen. Traveled in 1991 to Horsena Kunstmuseum, Lund, Sweden
Vollbild, Neue Gesellschaft für bildende Kunst (NGBK), Berlin
1989 *Art from Cologne,* Tate Gallery, Liverpool
Blickpunkte, Musée d'Art Contemporain de Montréal
Eye for I: Video Self-portraits, Independent

Hans Guck-in-die-Luft (Jack Look-in-the-Air). 1992–93. Single-channel video installation with projection. Shown installed at Galerie den Stadt Esslingen, Villa Merkel, 1993. Produced by, and collection of, the artist

Curators Incorporated, New York
Karl Schmidt-Rottluff Stipendium, Städtische Kunsthalle, Dusseldorf; Kunsthaus Zürich
Sei Artisti tedeschi, Castello di Rivara, Turin
Video-Skulptur: Retrospektiv und aktuell 1963–1989, Kölnischer Kunstverein, Cologne; Neuer Berliner Kunstverein, Kongreßhalle, Berlin; Kunsthaus Zürich
1990 *Berlin: März 1990,* Wiensowski Harbord, Berlin; Braunschweiger Kunstverein, Braunschweig; V.I.P. Galerie du Génie, Paris
Dialoghi tra Film, Video, Televisione, Taormina Arte (1990, 1991)
Kunstminen, Städtisches Kunstmuseum, Dusseldorf
Passages de l'image, Musée National d'Art

Moderne, Centre Georges Pompidou, Paris. Traveled in 1991 to the Centre Cultural, Fundació, Caixa de Pensions, Barcelona, and the Wexner Center for the Visual Arts, Ohio State University, Columbus; and in 1992, to the San Francisco Museum of Modern Art
1991 4e Semaine Internationale de Vidéo, Saint-Gervais-Genève
Fukui International Video Biennale
Metropolis, Martin-Gropius-Bau, Berlin
Rentâ Preis, Kunsthalle Nürnberg
Zone D—Innenraum, Förderkreis der Leipziger Galerie für Zeitgenössische Kunst, Leipzig
1992 *Yvon Lambert collectionne,* Musée d'Art Moderne de la Communauté Urbaine de Ville, Villeneuve d'Ascq
Manifeste, Musée National d'Art Moderne, Centre Georges Pompidou, Paris
Molteplici Culture, Museo del Folklore, Rome; Château de Beychevelle, Beychevelle
Moving Image, Fundació Joan Miró, Barcelona; Kölner Kunstmarkt, Cologne; Kunsthalle Düsseldorf
Pour la Suite du monde, Musée d'Art Contemporain de Montréal
1993 *Deutschsein,* Kunsthalle Düsseldorf
Fireproof, Wandelhalle, Cologne
Mediale, Deichtorhallen, Hamburg
1994 *Züge, Züge: Die Eisenbahn in der zeitgenössischen Kunst,* Städtische Galerie Göppingen
Cocido y crudo, Museo Nacional Centro de Arte Reina Sofía, Madrid
4 × 1, Museum Albertinum, Staatliche Kunstsammlungen, Dresden
1995 ARS '95 Helsinki, Museum of Contemporary Art, Helsinki

Selected Bibliography

Art from Cologne (Liverpool: Tate Gallery Liverpool, 1989).
Asher, Dan. "Marcel Odenbach," *Journal of Contemporary Art* 7 (Summer 1994).
Bellour, Raymond, Catherine David, Christine van Assche, et al. *Passages de l'image* (Paris: Musée National d'Art Moderne, Centre Georges Pompidou, 1990).
Blanchette, Manon, and Max Wolfgang Faust. *Blickpunkte* (Montreal: Musée d'Art Contemporain de Montréal, 1989).
Cocido y crudo (Madrid: Museo Nacional Centro de Arte Reina Sofía, 1994).
Fuller, Gregory. *Endzeitstimmung: Düstere Bilder in goldener Zeit* (Cologne: DuMont, 1994).
German Video and Performance: Wulf Herzogenrath, Ulrike Rosenbach, Marcel Odenbach, Jochen Gerz, Klaus Vom Bruch (Toronto: A Space, 1980).
Magnani, Gregorio. *Sei Artisti tedeschi* (Turin: Franz Paludetto, 1989).
Marcel Odenbach (Boston: Institute of Contemporary Art, 1986).
Marcel Odenbach (Madrid: Museo Nacional Centro de Arte Reina Sofía, 1989).
Marcel Odenbach: Dans la Vision périphérique du témoin (Paris: Musée National d'Art Moderne, Centre Georges Pompidou, 1987).
Marcel Odenbach: Keep in View (Stuttgart: Edition Cantz, 1993).
Marcel Odenbach: Stehen ist Nichtumfallen, ed. Andreas Vowinckel (Karlsruhe: Badischer Kunstverein, 1988).
Marcel Odenbach: Videoarbeiten, ed. Zdenek Felix (Essen: Museum Folkwang; Munich: Städtische Galerie im Lenbachhaus, 1981).
Marcel Odenbach: Video-Arbeiten, Installationen, Zeichnungen, 1988–1993/Videos, Installations, Drawings, 1988–1993, ed. Renate Damsch-Wiehager (Stuttgart: Edition Cantz, 1993).
Video-Skulptur: Retrospektiv und aktuell 1963–1989, eds. Wulf Herzogenrath and Edith Decker (Cologne: DuMont, 1989).
Wiensowski, Ingeborg, and Rudolf Bonvie. *Berlin: März 1990* (Brunswick: Braunschweiger Kunstverein, 1990).
Zeitzeichen: Stationen bildender Kunst in Nordrhein-Westfalen, ed. Karl Ruhrburg (Cologne: DuMont, 1989).
Züge, Züge: Die Eisenbahn in der zeitgenössischen Kunst, eds. Werner Meyer and Renate Damsch-Wiehager (Stuttgart: Edition Cantz, 1994).

Marcel Odenbach
Born 1953, Cologne
Lives in Cologne

Vicious Dogs. 1991. Three-channel video installation with text. Shown installed at the Jack Schainman Gallery, New York, 1992. Produced by the artist. Collection of the Städtische Galerie im Lenbachhaus, Munich

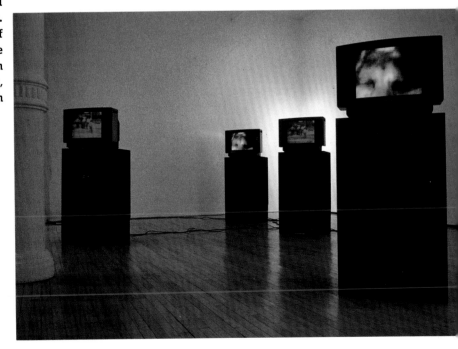

SYSTEM FOR DRAMATIC FEEDBACK

1994. Ten-channel video/sound installation with nine small video projectors that animate a group of rag dolls, and one large projection. Shown installed at Portikus, Frankfurt-am-Main, 1994. Produced by Portikus. Collection of the artist

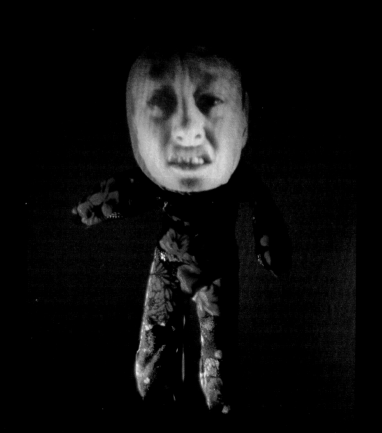

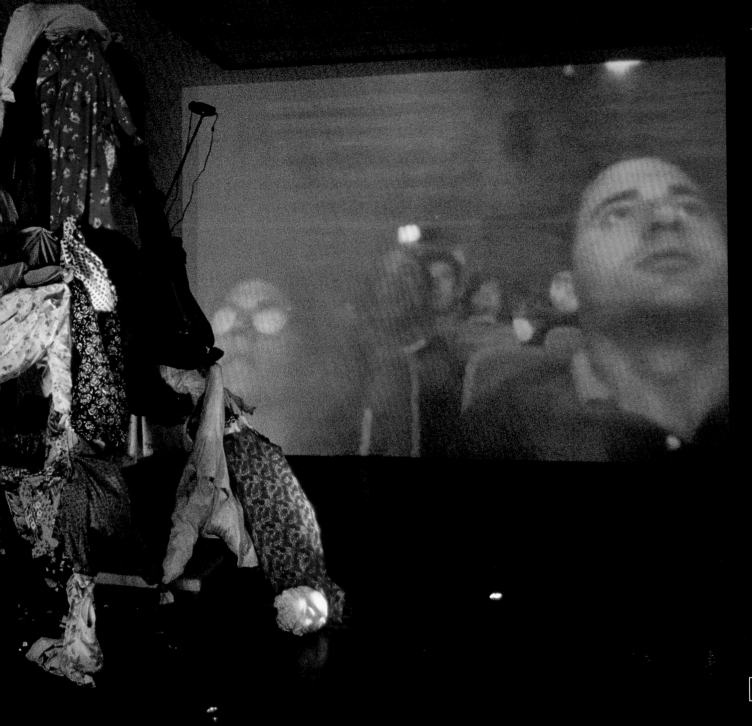

Tony
Oursler

The Weak Bullet. 1980. Videotape. Color. Stereo sound. 13 min.

Grand Mal. 1981. Videotape. Color. Stereo sound. 23 min.

Selected Solo Exhibitions

1981 The School of the Art Institute of Chicago
University Art Museum, University of California, Berkeley
Video Viewpoints, The Museum of Modern Art, New York
1982 Boston Film/Video Foundation
Complete Works, The Kitchen, New York
A Scene, P.S. 1, New York
Soho TV, Manhattan Cable Television
Walker Art Center, Minneapolis
1983 Los Angeles Contemporary Exhibitions
La Mamelle, San Francisco
My Sets, Media Study, Buffalo
Son of Oil, A Space, Toronto
X Catholic (performance with Mike Kelley), Beyond Baroque, Los Angeles
1984 Anthology Film Archives, New York
L-7, L-5, The Kitchen, New York
Mo David Gallery, New York
1985 The American Center, Paris
Espace Lyonnais d'Art Contemporain, Lyons
Kijkhuis, The Hague
Schule für Gestaltung, Basel
1986 Boston Film/Video Foundation
New Langton Arts, San Francisco
Nova Scotia College of Art and Design, Halifax
Sphères d'influence: Tony Oursler, Musée National d'Art Moderne, Centre Georges Pompidou, Paris
1987 The Kitchen, New York
1988 *Constellation: Intermission,* Diane Brown Gallery, New York

EVOL. 1984. Videotape. Color. Stereo sound. 29 min.

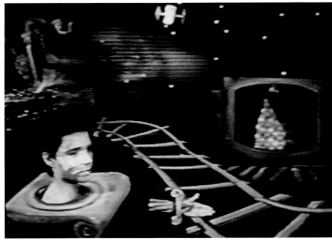

Joy Ride. 1988. Videotape. Color. Stereo sound. 14 min. Coproduced with Constance DeJong

69

Western Front, Vancouver
Tony Oursler and Constance DeJong, Los Angeles Center for Photographic Studies/EZTV Video Gallery, Los Angeles
Tony Oursler's Works, Le Lieu, Quebec
1989 Bobo Gallery, San Francisco
Collective for Living Cinema, New York
Drawings, Objects, Videotapes, Delta Gallery, Dusseldorf; Museum Folkwang, Essen
Museum für Gegenwartskunst, Basel
Relatives (video/performance with Constance DeJong), The Kitchen, New York; Rockland Center for the Arts, West Nyack; Seattle Art Museum; Mikery Theatre, Amsterdam; ECG-Studios, Frankfurt-am-Main

1990 Diane Brown Gallery, New York
Hallwalls, Buffalo
The Kitchen, New York
On Our Own, Segue Gallery, New York
1991 Diane Brown Gallery, New York
The Cinematheque, San Francisco
Dummies, Hex Signs, Watercolours, The Living Room, San Francisco
The Pacific Film Archives, San Francisco
1992 *F/X Plotter, 2 Way,* Kijkhuis, The Hague
The Knitting Factory, New York
The Space, Boston
Station Project (with James Casebere), Kortrijk, The Netherlands
1993 Kunstwerke, Berlin
IKON Gallery, Birmingham; Bluecoat Gallery, Liverpool
The Living Room, San Francisco
Phobic/White Trash, Centre d'Art Contemporain, Geneva; Andrea Rosen Gallery, New York; Kunstwerke, Berlin
1994 Jean Bernier Gallery, Athens, Greece
Dummies, Flowers, Alters, Clouds, and Organs, Metro Pictures, New York
Judy, Salzburger Kunstverein, Salzburg
Galleria Galliani, Genoa
Lisson Gallery, London
System for Dramatic Feedback, Portikus, Frankfurt-am-Main
1995 Centre d'Art Contemporain Genève, Geneva
Tony Oursler: Installations, vidéo, objets, et aquarelles, Musée des Art Moderne et Contemporain, Strasbourg

Selected Group Exhibitions

1984 *The Luminous Image,* Stedelijk Museum, Amsterdam
1987 Documenta VIII, Kassel
L'Epoque, la mode, la morale, la passion, Musée National d'Art Moderne, Centre Georges Pompidou, Paris
Japan 1987 Television and Video Festival, Spiral, Tokyo
Schema, Baskerville + Watson Gallery, New York
1988 *The BiNational: American Art of the Late 80s, German Art of the Late 80s/ Amerikanische Kunst der späten 80er Jahre, Deutsche Kunst der späten 80er Jahre,* Institute of Contemporary Art and Museum of Fine Arts, Boston; Städtische Kunsthalle, Dusseldorf; Kunsthalle Bremen; Württembergischer Kunstverein, Stuttgart
Festival International du Nouveau Cinéma et de la Vidéo, Montreal
Infermental 7, Hallwalls, Buffalo
New York Dagen, Kunstichting, Rotterdam
Replacement, Los Angeles Contemporary Exhibitions
Serious Fun Festival (installation), Alice Tully Hall, Lincoln Center for the Performing Arts, New York
Third Videonale, Bonn
Twilight: Festival Belluard 88 Bollwerk, Fribourg

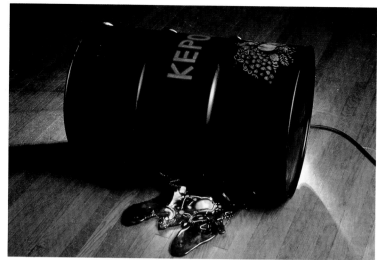

Kepone Drum. 1990. Single-channel video installation with steel drum and poured glass. Private installation. Produced by, and collection of, the artist

Judy (detail). 1994. Mixed-media installation with sound. Shown installed at the Salzburger Kunstverein, Salzburg, 1994. Produced by the Salzburger Kunstverein and the artist. Collection of the artist

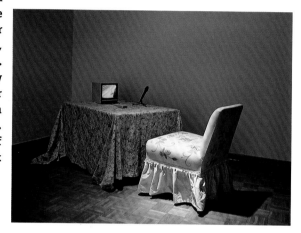

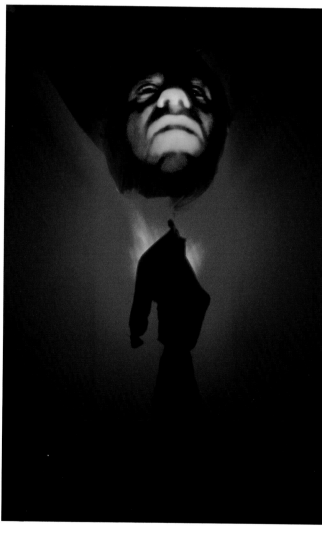

F/X Plotter (#1). 1992. Single-channel video/sound installation. Shown installed at the Kijkhuis, The Hague, 1992. Produced by the artist. Private collection, Belgium

Tony Oursler
Born 1957, New York
Lives in New York

Videografia, Barcelona
World Wide Video Festival, Kijkhuis, The Hague (1988, 1989)
1989 *Masterpieces,* Stadtgarten, Cologne
Nepotism, Hallwalls, Buffalo
Sanity Is Madness, The Artists Foundation Gallery, Boston
XII Salso Film & TV Festival, Salsomaggiore Incontri Cinematografici, Rome
Video and Language, The Museum of Modern Art, New York
Video-Skulptur: Retrospektiv und aktuell 1963–1989, Kölnischer Kunstverein, Cologne; Neuer Berliner Kunstverein, Kongreßhalle, Berlin; Kunsthaus Zürich
Whitney Biennial, Whitney Museum of American Art, New York
1990 *The Technological Muse,* Katonah Museum of Art, Katonah, New York
Tendance Multiples: Vidéo des années 80, Musée National d'Art Moderne, Centre Georges Pompidou, Paris
Video/Objects/Installations/Photography, Howard Yezerski Gallery, Boston
Video Transforms Television— Communicating Unease, New Langton Arts, San Francisco
1991 Documenta IX, Kassel
New York Times Festival, Museum van Hedendaagse Kunst, Ghent
Triune, Video Positive Festival, Bluecoat Gallery, Liverpool
1993 ARTEC '93, Nagoya City Art Museum
Love Again, Kunstraum Elbschloss
Privat, Gallery F-15, Oslo
1994 *Beeld/Beeld,* Museum van Hedendaagse, Ghent
Galleria Galliani, Genoa
The Figure, The Lobby Gallery, Deutsche Bank, New York
Marian Goodman Gallery, New York
Medienbiennale 94: Minima Media, Leipzig
Metro Pictures, New York
Oh Boy, It's a Girl: Feminismus in der Kunst, Kunstverein München
1995 ARS '95 Helsinki, Museum of Contemporary Art, Helsinki
Zeichen Wunder, Kunsthaus Zürich

Selected Bibliography

Berlinsky, John. "The Light Fantastic," *Metro* (October 1988).
Carr, C. "Constance DeJong and Tony Oursler: Relatives, The Kitchen," *Artforum* 27 (May 1989).
Cornwell, Regina. "Great Videos, Shame about the Show," *Art Monthly,* no. 159 (September 1992).
Decter, J. "Tony Oursler, Diane Brown Gallery," *Arts* 65 (October 1990).
Duncan, Michael. "Tony Oursler at Metro Pictures," *Art in America* 83 (January 1995).
Fargier, Jean Paul. "Installation à Beaubourg, Paris," *Cahiers du Cinéma,* no. 380 (February 1986).
Hagen, Charles. "Video Art: The Fabulous Chameleon," *ARTnews* 88 (Summer 1989).
Janus, Elizabeth. *Tony Oursler: White Trash and Phobic* (Geneva: Centre d'Art Contemporain, 1993).
Labat, Tony. "Tony Oursler," *Shift* 5 (1991).
Lalanne, Dorothée. "Tony Oursler: Dernier Soir," *Cinéma,* no. 10 (February 1986).
Lange, Regina. "Media-Power: Videoarbeiten von Tony Oursler," *Apex-Heft* 7 (1989).
Lintinen, Jaako. "Uudella mediataiteella taitaa olla halussaan 90-luvun avaimet," *Taide,* no. 30 (1990).
Miller, John. "Tony Oursler, Diane Brown Gallery," *Artforum* 29 (October 1990).
Minkowsky, John, Christina Ritchie, and Christine van Assche. *Sphères d'influence: Tony Oursler* (Paris: Musée National d'Art Moderne, Centre Georges Pompidou, 1986).
Oursler, Tony. "Phototrophic," *Illuminating Video: An Essential Guide to Video Art,* eds. Doug Hall and Sally Jo Fifer (New York: Aperture; Bay Area Video Coalition, 1990).
———. "Triune: A Work in Progress," *Visions* 5 (Summer 1991).
———. "Vampire," *Communications Video* 48 (November 1988).
Tony Oursler, ed. Friedemann Malsch (Frankfurt-am-Main: Portikus, 1995).
Puvogel, Renate. "Tony Oursler: System for Dramatic Feedback," *Kunstforum,* no. 127 (November 1994).
Ramirez, Y. "Diane Brown Gallery," *Art in America* 80 (May 1992).
Sage, Elspeth. "The Joy of Collaboration: An Interview with Constance DeJong and Tony Oursler," *Vancouver Guide,* no. 4 (1988).
Sandqvist, Gertrud. "Privat," *Parkett,* no. 37 (1993).
Schwendener, Martha. "Tony Oursler: Dummies, Flowers, Alters, Clouds, and Organs," *Art Papers* 19 (January–February 1995).
Tiberio, Margaret. "Method to This Media: An Interview with Tony Oursler," *Visions* 3 (Summer 1989).

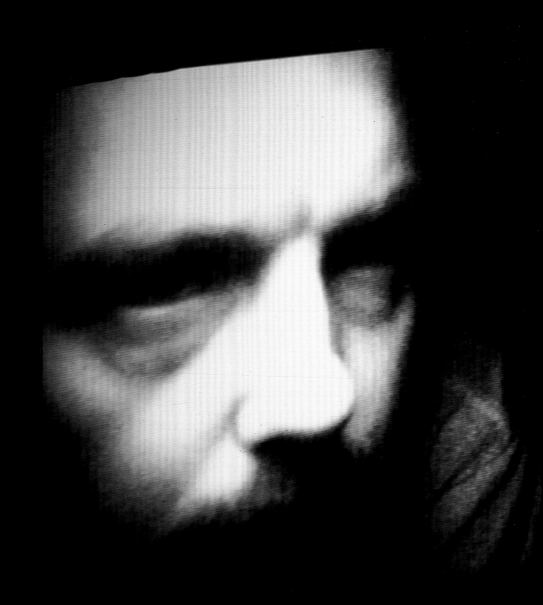

SLOWLY
TURNING
NARRATIVE

1992. Computer-controlled,
two-channel video/sound instal-
lation with two video projectors
and two sound systems. Images
are projected onto a freestanding wall,
9' ¼" × 11' 9¾", that rotates on a central
axis. Shown installed at the Institute of
Contemporary Art, Philadelphia, 1992.
Commissioned by the Virginia Museum of
Fine Arts, Richmond, and the Institute
of Contemporary Art. Collection of the artist

Bill Viola

I Do Not Know What It Is I Am Like. 1986. Videotape. Color. Stereo sound. 89 min.

Tiny Deaths (detail). 1993. Three-channel video/sound installation. Shown installed at the Biennale d'Art Contemporain de Lyon, Halle Tony Garnier. Collection of the Musée d'Art Contemporain, Lyons

The Passing.
1991.
Videotape.
Black-and-white.
Mono sound. 54 min.

Hatsu Yume. (First Dream). 1981. Videotape. Color. Stereo sound. 56 min.

Bill Viola: In the Mind's Eye: A Sacred Space, Oriel Art Gallery, Cardiff
1994 *Bill Viola: "Stations,"* American Center (Inaugural), Paris
Bill Viola: Território do Invisível—Site of the Unseen, Centro Cultural/Banco do Brazil, Rio de Janeiro
Wien Modern, Konzerthaus Wien, Vienna (premiere of the film *Déserts*, with music by Edgard Varése performed by Ensemble Modern)
1995 *Bill Viola: Buried Secrets*, U.S. Pavilion, Venice Biennale

Selected Group Exhibitions

1972 *St. Jude Invitational Exhibition*, De Saisset Art Gallery and Museum, Santa Clara
1974 *Art Now*, Kennedy Center, Washington, D.C.
Projekt 74, Kölnischer Kunstverein, Cologne
1975 La Biennale de Paris, ARC, Musée d'Art Moderne de la Ville de Paris (1975, 1977)
Video Art, Institute of Contemporary Art, Philadelphia
Whitney Biennial, Whitney Museum of American Art, New York (1975–87, 1993)
1976 *Beyond the Artist's Hand: Explorations of Change*, Art Gallery, California State University, Long Beach
Video-Art: An Overview, San Francisco Museum of Modern Art
1977 Documenta VI, Kassel
1978 *International Open Encounter on Video*, Tokyo
1979 *Everson Video Review*, Everson Museum of Art, Syracuse
1981 *International Video Art Festival*, Theme Pavilion, Portopia '81, Kobe
1982 *60'80 attitudes/concepts/images*, Stedelijk Museum, Amsterdam
Sydney Biennial, Art Gallery of New South Wales, Sydney
1983 *Art vidéo: Rétrospective et perspectives*, Palais des Beaux-Arts de Charleroi
1984 *The Luminous Image*, Stedelijk Museum, Amsterdam

1985 *Currents*, Institute of Contemporary Art, Boston
Summer 1985, Museum of Contemporary Art, Los Angeles
1986 Festival Nacional de Video, Circulo de Bellas Artes, Madrid
Venice Biennale
1987 *The Arts for Television*, Stedelijk Museum, Amsterdam; Museum of Contemporary Art, Los Angeles. Traveled in Europe and North America, 1987–89
Avant-Garde in the Eighties, Los Angeles County Museum of Art
L'Epoque, la mode, la morale, la passion: Aspects de l'art d'aujourd'hui, Musée National d'Art Moderne, Centre Georges Pompidou, Paris
Japan 87 Video Television Festival, Spiral, Tokyo
Videokunst, Schleswig-Holsteinischer Kunstverein and Kunsthalle zu Kiel der Christian-Albrechts-Universität, Kiel
1988 Carnegie International, The Carnegie Museum of Art, Pittsburgh
American Landscape Video, The Electronic Grove, The Carnegie Museum of Art, Pittsburgh
1989 *Image World, Art and Media Culture*, Whitney Museum of American Art, New York
Video-Skulptur: Retrospektiv und aktuell 1963–1989, Kölnischer Kunstverein, Cologne; Neuer Berliner Kunstverein, Kongreßhalle, Berlin; Kunsthaus Zürich
1990 Bienal de la Imagen en Movimiento '90, Museo Nacional Centro de Arte Reina Sofía, Madrid
LIFE-SIZE: A Sense of the Real in Recent Art, The Israel Museum, Jerusalem
Passages de l'image, Musée National d'Art Moderne, Centre Georges Pompidou, Paris. Traveled in 1991 to the Centre Cultural, Fundació, Caixa de Pensions, Barcelona, and the Wexner Center for the Visual Arts, Ohio State University, Columbus; and in 1992, to the San Francisco Museum of Modern Art
1991 *Metropolis*, Martin-Gropius-Bau, Berlin
Opening Exhibition, Museum für Moderne

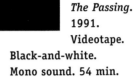

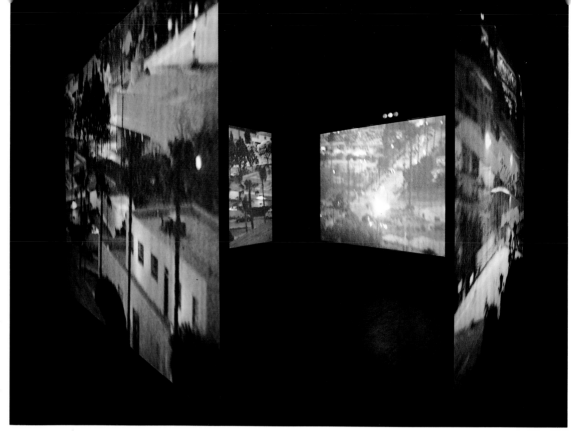

The Stopping Mind. 1991. Computer-controlled, four-channel video/sound installation with four projectors and sound system. Commissioned by, and collection of, the Museum für Moderne Kunst, Frankfurt-am-Main

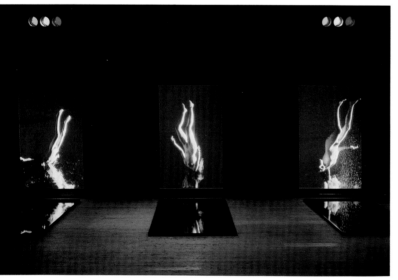

Stations. 1994. Computer-controlled, five-channel video/ sound installation with five black granite slabs, each 2½" × 5' 10" × 9' 3". Commissioned by The Bohen Foundation for the inauguration of the American Center, Paris. Collection of The Bohen Foundation, New York

Kunst, Frankfurt-am-Main
1992 *Art at the Armory: Occupied Territory,* Museum of Contemporary Art, Chicago
Documenta IX, Kassel
Pour la Suite du monde, Musée d'Art Contemporain de Montréal
1993 Biennale d'Art Contemporain de Lyon, Halle Tony Garnier
Feuer, Wasser, Erde, Luft—Die vier Elemente, Mediale, Deichtorhallen, Hamburg
Labyrinth of the Spirit, The Hammond Galleries, Lancaster, Ohio
New World Images, Louisiana Museum of Modern Art, Humlebaek
1994 *Beeld/Beeld,* Museum van Hedendaagse Kunst, Ghent
Ik + de Ander: Dignity for All: Reflections on Humanity, Beurs van Berlage, Amsterdam
Landscape as Metaphor, Denver Art Museum and Columbus Museum of Art

Selected Bibliography

Bellour, Raymond. "An Interview with Bill Viola," *October,* no. 34 (Fall 1985). Published in French in two parts: *Cahiers du Cinema,* no. 379 (January 1986); *Cahiers du Cinema,* special issue, "Où va la vidéo?," ed. Jean-Paul Fargier (1986).

Daniels, Dieter. "Bill Viola: Installations and Videotapes," *Kunstforum,* no. 92 (December 1987–January 1988).

Duguet, Anne-Marie. "Les Vidéos de Bill Viola: Une Poétique de l'espace-temps," *Parachute,* no. 45 (December 1986–February 1987).

Feldman, Melissa, and H. Ashley Kistler. *Slowly Turning Narrative* (Philadelphia: Institute of Contemporary Art; Richmond: Virginia Museum of Fine Arts, 1992).

Gauville, Hervé. "La Compassion selon Bill Viola," *Vogue* (Paris), October 1994.

Hanhardt, John. "Cartografando il visibile. L'Arte di Bill Viola," *Ritratti: Greenaway, Martinis, Pirri, Viola*, ed. Valentina Valentini (Taormina: Taormina Arte, Parco Duca di Cesaro, 1987).

Hoberman, J. "Video Art: Paradoxes and Amusement Parks," *American Film* 6 (April 1981).

Kuspit, Donald. "The Passing," *Artforum* 32 (September 1993).

London, Barbara. "Bill Viola: Entropy and Disorder," *Image Forum*, no. 116 (December 1989).

Nash, Michael. "Bill Viola," *Journal of Contemporary Art* 3 (Fall–Winter 1990).

Sturken, Marita. "Temporal Interventions," *Afterimage*, no. 10 (Summer 1982).

Torcelli, Nicoletta. "Bill Viola: The Silent Power of the Image," *Das Kunst-Bulletin* (December 1992).

Viola, Bill. "The Body Asleep," *Pour la Suite du monde, Cahiers: Propos et projets*, eds. Gilles Godmer and Réal Lussier (Montreal: Musée d'Art Contemporain de Montréal, 1992). In French and English.

———. "History, 10 Years and the Dreamtime," *Video: A Retrospective, Long Beach Museum of Art, 1974–1984*, ed. Kathy Huffman (Long Beach, Calif.: Long Beach Museum of Art, 1984).

———. "Perception, Technology, Imagination, and the Landscape," *Enclitic* 11 (July 1992).

———. "Sight Unseen—Enlightened Squirrels and Fatal Experiments," *Video 80*, no. 4 (Summer 1982).

———. "The Sound of One Line Scanning," *Sound by Artists*, eds. Dan Lander and Micah Lexier (Toronto: Art Métropole; Banff: Walter Phillips Gallery, 1990). Published in French as "Le Son d'une ligne de balayage," *Chimères* 11 (Spring 1991).

———. "Video Black—The Mortality of the Image," *Illuminating Video: An Essential Guide to Video Art*, eds. Doug Hall and Sally Jo Fifer (New York: Aperture; Bay Area Video Coalition, 1990).

———. "Bill Viola: Statements by the Artist," *Summer 1985*, ed. Julia Brown (Los Angeles: Museum of Contemporary Art, 1985).

———. "Will There Be Condominiums in Data Space?" *Video 80*, no. 5 (Fall 1982).

Bill Viola, ed. Josée Belisle (Montreal: Musée d'Art Contemporain de Montréal, 1993).

Bill Viola, ed. Dany Bloch (Paris: ARC, Musée d'Art Moderne de la Ville de Paris, 1983).

Bill Viola, ed. Alexander Pühringer (Salzburg: Salzburger Kunstverein, 1994).

Bill Viola: Images and Spaces, coord. Tina Yapelli, with Toby Kamps (Madison, Wis.: Madison Art Center, 1994).

Bill Viola: Installations and Videotapes, ed. Barbara London (New York: The Museum of Modern Art, 1987).

Bill Viola: Survey of a Decade, ed. Marilyn Zeitlin (Houston: Contemporary Arts Museum, 1988).

Bill Viola: Território do Invisível—Site of the Unseen, ed. Marcello Dantas (Rio de Janeiro: Centro Cultural/Banco do Brasil, 1994).

Bill Viola: Unseen Images, ed. Marie Luise Syring (Dusseldorf: Städtische Kunsthalle, 1992).

Video-Skulptur: Retrospektiv und aktuell 1963–1989, eds. Wulf Herzogenrath and Edith Decker (Cologne: DuMont, 1989).

Youngblood, Gene. *Metaphysical Structuralism: The Videotapes of Bill Viola* (Los Angeles: Voyager Press, 1986).

Bill Viola
Born 1951, New York
Lives in Long Beach, California

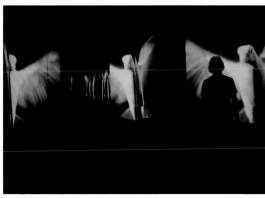

Heaven and Hell. 1985. Single-channel video/sound installation in two rooms, with one projector and one monitor. Shown installed at the San Francisco Museum of Modern Art, 1985. Produced by the artist and the San Francisco Museum of Modern Art. Collection of the artist

Photograph Credits

The Amazing Decade: Women's Performance in America, 1970–1980, ed. Moira Roth (Los Angeles: Astro Artz, 1983).

The Arts for Television, eds. Kathy Rae Huffman and Dorine Migot (Los Angeles: Museum of Contemporary Art; Amsterdam: Stedelijk Museum, 1987).

Bellour, Raymond, Catherine David, Christine van Assche, et al. *Passages de l'image* (Paris: Musée National d'Art Moderne, Centre Georges Pompidou, 1990).

Boyle, Deirdre. *Video Classics: A Guide to Video Art and Documentary Tapes* (Phoenix: Onyx Press, 1986).

Davis, Douglas. *Art and the Future: A History-Prophecy of the Collaboration Between Science, Technology and Art* (New York: Praeger, 1973).

Delehanty, Suzanne. *Video Art* (Philadelphia: Institute of Contemporary Art, 1975).

Electronic Arts Intermix: Video, ed. Lori Zippay (New York: Electronic Arts Intermix, 1991).

Frampton, Hollis. *Circles of Confusion: Film, Photography, Video* (Rochester, N.Y.: Visual Studies Workshop Press, 1983).

Gruber, Bettina, and Maria Vedder. *Kunst und video* (Cologne: DuMont, 1983).

Illuminating Video: An Essential Guide to Video Art, eds. Doug Hall and Sally Jo Fifer (New York: Aperture; Bay Area Video Coalition, 1990).

Long Beach Museum of Art. *Southland Video Anthology 1976–77* (Long Beach, Calif.: Long Beach Museum of Art, 1977). Exhibition organized by David Ross.

Lovejoy, Margot. *Post Modern Currents: Art and Artists in the Age of Electronic Media* (Ann Arbor: University of Michigan, 1989).

Musée d'Art Contemporain de Montréal. *Western Front Video* (Montreal: Musée d'Art Contemporain de Montréal; Art Gallery of Hamilton, 1984).

New Artists Video: A Critical Anthology, ed. Gregory Battcock (New York: E. P. Dutton, 1978).

Resolution: A Critique of Video Art, ed. Patti Podesta (Los Angeles: Los Angeles Contemporary Exhibitions [LACE], 1986).

Ryan, Paul. *Cybernetics of the Sacred* (Garden City, N.Y.: Anchor Press/Doubleday, 1974).

Transmission: Theory and Practice for a New Television Aesthetics, ed. Peter D'Agostino (New York: Tanam Press, 1985).

Video, ed. René Payant (Montreal: Artextes, 1986).

Video Art: An Anthology, eds. Ira Schneider and Beryl Korot (New York: Harcourt Brace Jovanovich, 1976).

Video by Artists, ed. Peggy Gale (Toronto: Art Metropole, 1976).

Video by Artists 2, ed. Elke Towne (Toronto: Art Metropole, 1986).

Video Culture: A Critical Investigation, ed. John G. Hanhardt (Rochester, N.Y.: Visual Studies Workshop Press; Peregrine Smith Books, 1986).

Vidéo et aprés: La Collection vidéo du Musée National d'Art Moderne, Centre Georges Pompidou, ed. Christine van Assche (Paris: Edition Carré; Musée National d'Art Moderne, Centre Georges Pompidou, 1992).

Videokunst in Deutschland 1963–1982: Videobander, installationen, objekte, performances, ed. Wulf Herzogenrath (Cologne: Kölnischer Kunstverein, 1982).

Video-Skulptur: Retrospektiv und aktuell 1963–1989, eds. Wulf Herzogenrath and Edith Decker (Cologne: DuMont, 1989).

Youngblood, Gene. *Expanded Cinema* (New York: E. P. Dutton, 1970).

Bibliography

Trustees of The Museum of Modern Art